More HOW TO DRAW MANGA

MANGA

Vol. 1

The Basics of Character Drawing

MORE HOW TO DRAW MANGA Vol. 1: The Basics of Character Drawing
by Go Office

This book was first designed and published by Graphic-sha Publishing Co., Ltd. in Japan in 2002.
This English edition was published by Graphic-sha Publishing Co., Ltd. in Japan in 2004.

Artwork and Production:	Ushio, Shiomi Kohhara, Yumiko Deguchi, Hazumi Amano, Bakeko, RACHEL, Akira Gokita, Rio Yagizawa
Production Assistant:	Takumi Takahashi
Cover Artwork:	Kazuaki Morita
English Main Title Logo Design:	Hideyuki Amemura
Composition and Text:	Hikaru Hayashi, Rio Yagizawa (Go Office)
Reference Photography:	Yasuo Imai
Models:	naoko, take, and Seiko Oshikawa (Photography: Junichi Iijima)
English Edition Layout:	Shinichi Ishioka
English Translation Management:	Língua fránca, Inc. (an3y-skmt@asahi-net.or.jp)
Planning Editor:	Motofumi Nakanishi (Graphic-sha Publishing Co., Ltd.)
Foreign Language Edition Project Coordinator:	Kumiko Sakamoto (Graphic-sha Publishing Co., Ltd.)

Distributor:
Japan Publications Trading Co., Ltd.
1-2-1 Sarugaku-cho, Chiyoda-ku, Tokyo, 101-0064
Telephone: +81(0)3-3292-3751 Fax: +81(0)3-3292-0410
E-mail: jpt@jptco.co.jp
URL: http://www.jptco.co.jp/

First printing:	March 2004
Second printing:	August 2004
Third printing:	November 2004
Fourth printing:	January 2005
Fifth printing:	March 2007

ISBN 978-4-7661-1482-9
UPC 824869000489
Printed and bound in China

More HOW TO DRAW MANGA
Vol. 1
The Basics of Character Drawing

Be sure you know the basics!

New *Manga* Technique Series

More How to Draw Manga Vol. 1

Table of Contents

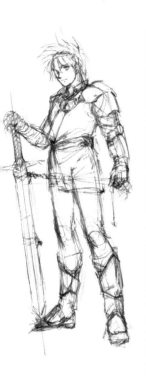

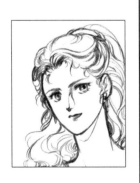

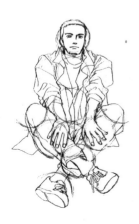

Foreword

Manga allows you to communicate many things. It is capable of communicating momentary feelings, like "I'm hungry," as well as multifaceted issues such as "How should we, the human race be ideally?"

Somewhere along the line, *manga* artists sprouted up overseas and became no longer limited to Japan. Today, *manga* is regarded internationally as an aspect of Japanese culture.

I personally enjoy drawing *manga* and anime characters and have drawn many since my early *manga* days. I eventually became a professional artist. Since then, I have discussed *manga* with other friends in the field, and everyone tends to agree that learning to draw with a pen was the first biggest hurdle.

Without being pen-based, *manga* would be a different art form. Yet, I think that if I had been required to be skilled with the pen right from the start, I would not have been able to enjoy continuing my new career. Despite this fact, I have yet to see a book on *manga* that says just that.

Doodling, a familiar pastime we indulge in at our leisure, lies at *manga*'s origins. Anything I cannot draw in pencil I certainly will not be able to draw in pen-at first, anyway. This fact still holds true. It is important that you feel unlimited in drawing your favorite *manga* and anime characters using a regular or mechanical pencil. Once you have mastered a wide range of things in pencil, then you will be able to enjoy rendering your *manga* in pen as well. It is based on that final sentiment that I have written this book.

Rio Yagizawa
Go Office

Chapter 1
Drawing in Pencil

Sketching and Doodling Are the First Steps Toward *Manga*.

Drawing freely flowing pictures from freely flowing ideas constitutes *manga*'s origins. All you need to start drawing are the ever-accessible pencil (or mechanical pencil) and paper.

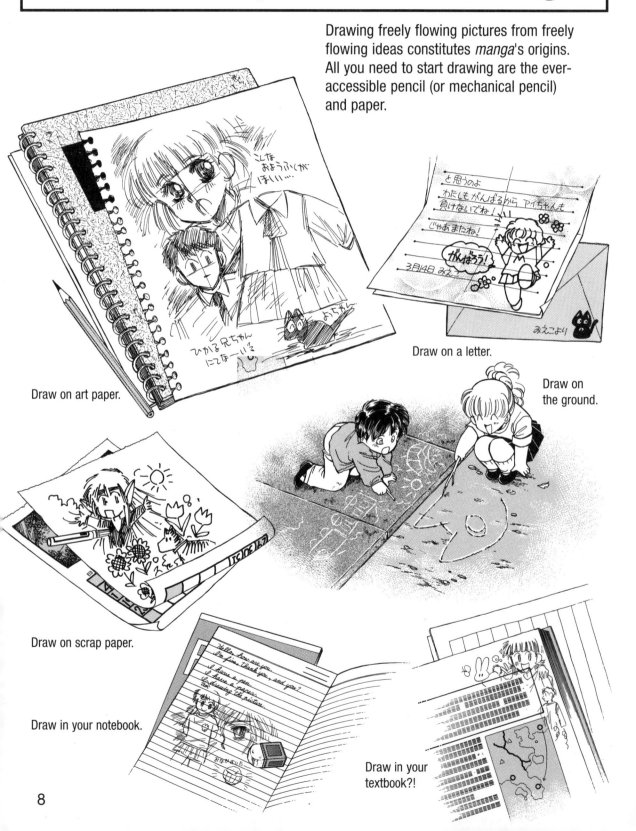

Draw on art paper.

Draw on a letter.

Draw on the ground.

Draw on scrap paper.

Draw in your notebook.

Draw in your textbook?!

Manga and illustrations all begin in pencil.

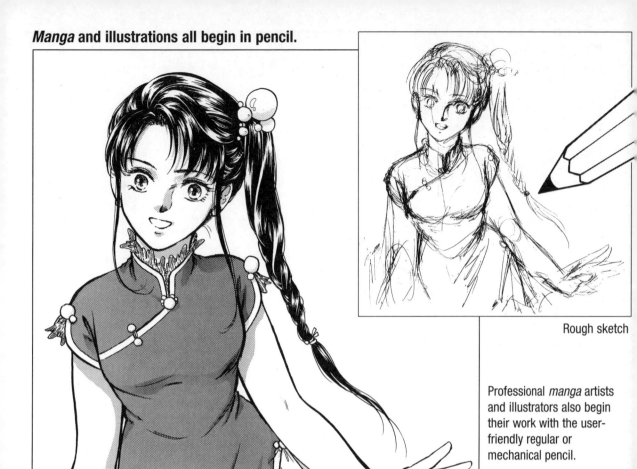

Final artwork

Rough sketch

Professional *manga* artists and illustrators also begin their work with the user-friendly regular or mechanical pencil.

Penciled drawing

Final, inked work

Original *Manga* and Illustrations for Publication Start in Pencil (Or Mechanical Pencil).

The Process

1. Under Drawing

(① to ③)

At this stage, the artist redraws the artwork any number of times until he or she feels satisfied. Produce the under drawing carefully, trying to recreate the image in your mind.

①

◀ Sketch roughly the overall panel layout, the positioning of any copy (speech balloons), as well as the characters and the composition.

Use a ▶ straightedge to draw the panel's lines. Create the characters' under drawings.

②

2. Inking

Ink the characters, background, and special effect lines. At this time, you may pen the panel lines, but there are artists who do this before producing the under drawing.

◀ Produce the under drawing for the background panels. At this time, pencil any reference lines using a straightedge.

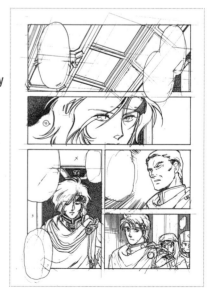

3. Erasing

You may do any erasing at the following times:
1) After you have finished inking the background; or
2) Once you have inked the characters, you can then erase as needed.

Afterwards, you complete the background's under drawing and then again erase as needed.

In either case, pencil smears more than you might think and tends to grey the artwork overall, so you will need to go over the entire paper with your eraser.

4. Spotting Blacks

Here, you fill in any area needed with India ink or marker. Erasing after adding blacks tends to cause smudges, so be sure to add blacks after using the eraser.

5. White

Use white poster paint and a brush or correction fluid to clean up any marks between panel lines or inside of speech balloons or any over drawn lines. This is preparatory work for attaching tone.

6. Screen Tone

Attach the screen tone, check for any extra eraser bits or white, or any unevenly filled blacks, and you're finished.

• This is the standard process followed up to the inking. Work after that does not necessarily have to follow the order shown.

Creating Postcard-size Illustrations

A postcard is about the same size as a single panel on an original *manga* copy. Consequently, practicing composition and balance for a postcard, whether vertical or horizontal, also makes for reasonable *manga* practice.

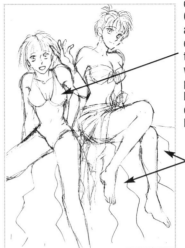

A one-piece swimsuit is transformed into a bikini during the inking process. Once you have become accustomed to under drawings, you will be able to modify them in pen without having to fix it in pencil first. Beginners will have to adjust the under drawing first; otherwise, a huge mistake could result.

These "watermelon stripes" are indistinguishable to an observer at the under drawing stage. Only you, the artist, need know what is represented in the drawing at this stage.

Since the under drawing establishes the layout, copy may be added at this stage. You may also go ahead and mark down where to add solid blacks and screen tone numbers.

Clothing and hair tend to have more lines at this stage. The under drawing primarily serves the purpose of devising the final image.

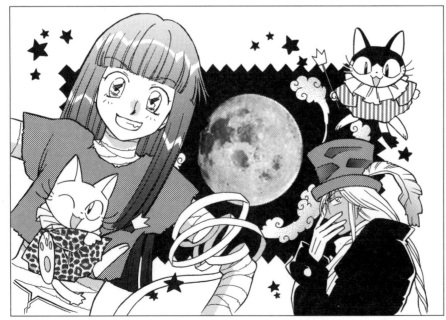

10 cm
(approx. 3 7/8")

15 cm
(approx. 5 7/8")

If you use a uniform paper size to create not only a close-up of faces, but also compositions showing full figures, etc., before you realize it, you will be able to produce any sized composition.

The postcard illustration process

This process is almost identical to that for a *manga* original copy.

① Produce a rough layout sketch in pencil, plotting the composition in general terms. Artists often redo the sketch any number of times at this stage, until they arrive at their desired image. Drawing a postcard-sized frame on a slightly larger piece of paper will make this easy.

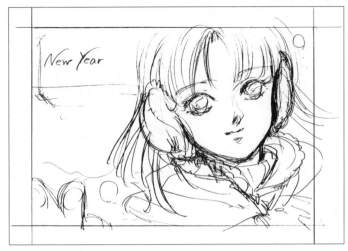

② Produce an under drawing based on the rough sketch.

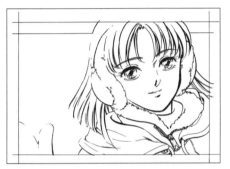

③ Ink the lines and clean it up with an eraser.

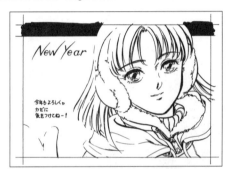

④ Draw the background and spot blacks.

⑤ Add white touches and attach the screen tone. Cut along the panel lines and presto! (Actual size)

If you are planning to mail your postcard, use permanent ink or enclose it in an envelope and send it as a greeting card.

Sample Postcards

All of these were originally drawn postcard-size. If you photocopy any of these at 127%, then you will see the thickness used for the original lines and the degree of screen tone detail.

Draw the rest of the body even when depicting just the head.

— The recipe to becoming a good artist

Artists occasionally find they have become proficient at faces but are lost when it comes to bodies. If you make it a habit to draw the body along with the head, then when you are forced to perform, you will be ready.

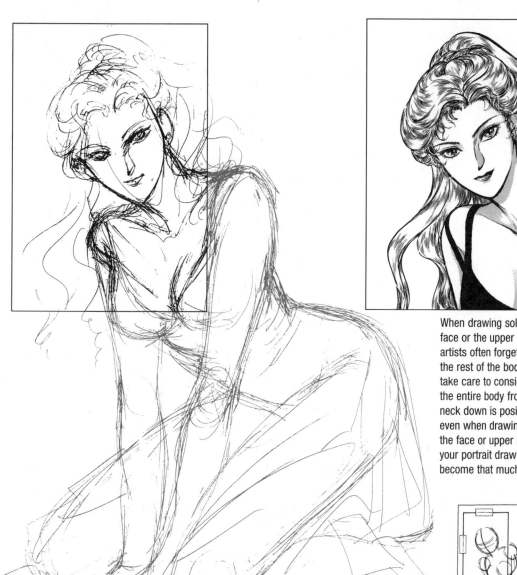

When drawing solely the face or the upper body, artists often forget about the rest of the body. If you take care to consider how the entire body from the neck down is positioned even when drawing just the face or upper body, your portrait drawings will become that much better.

Common Pitfalls When Only What Is Visible Was Drawn

At first glance, this seems like a normal illustration.

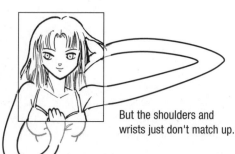

But the shoulders and wrists just don't match up.

The Under Drawing Process

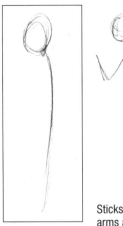

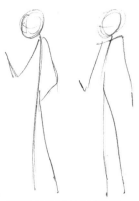

Sticks may be used for the arms and legs.

① Create a rough layout sketch. Here, you will lay out the target composition in general terms. Play around with the pose or the hands' positions until you are certain you have captured the image in your mind.

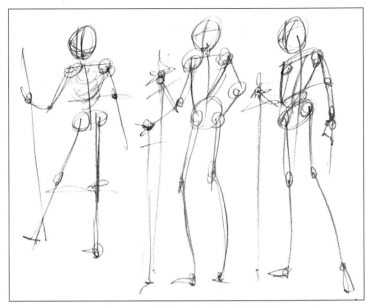

The torso is abbreviated at this stage (see above). There are artists who, at the layout sketch stage, will either use an oval for the torso or break it down, using an inverted triangle for the chest plus a lengthwise oval for the hips. The joints are often rendered as circles.

Here, a head is rendered as a circle with an X used to determine the direction faced.

While a portion of the right arm is hidden behind the chest, draw the arm imagining how the hidden part appears, starting from the shoulder on downward.

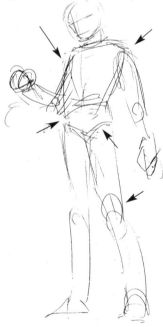

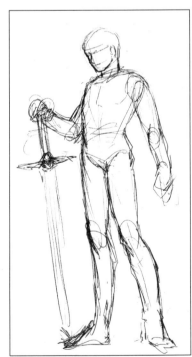

② Once the image is set, adjust the overall form based on the layout sketch. Draw the body in blocks: the head, the arms and legs, and the torso. Use circles for the joints and curved contours suggestive of the muscles' volume for the silhouette lines.

This figure shows the body laid out in blocks. Once you have grown accustomed to sketching, you will be able to start from this point. The key is to use curved lines for the hips and groin, the knees, shoulders, and other joints, since they are regions where body parts connect.

③ Draw the body's contours. Adjust the general positioning of the knees and shoulders while you draw in order to confirm their correct placement. Sketch in any props (here, a sword).

16

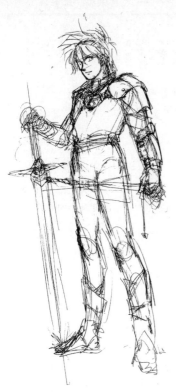

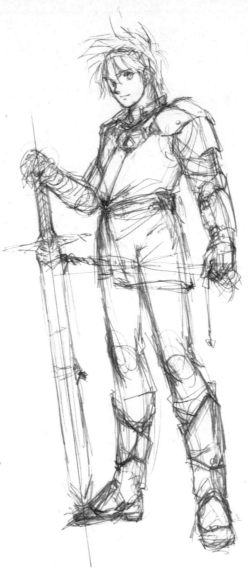

④ Draw the face, hair, clothes, etc. You may design the face and clothing as you draw, or you may use something you have already designed beforehand. With respect to the sword's central line, etc., artists will often add props after inking all human figures.

The above shows a cleaned up under drawing. There are artists who will render the penciled under drawing to virtually the same level as the inked drawing.

⑤ Here we see the completed under drawing. Although to the observer it may seem sketchy and indistinct, this is not a problem, provided that you, the artist, have a clear grasp of the drawing during the inking process.

Can the under drawing be skipped?

Under drawing

This penned drawing was produced sans under drawing. (I looked at the subject while drawing in pen.) Line modulation and other aspects are unbalanced. The shapes of the cheeks and eyes are awkward.

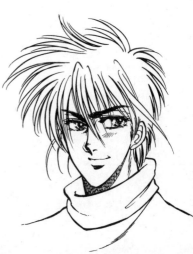

This penned drawing was based on an under drawing. The inking process went smoothly, and the final image is a clean version of the under drawing.

The Type of Pencil Depends on the Composition's Size.

Use HB or B leads for small compositions.

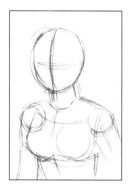

At the rough sketch stage, draw lightly and avoid putting too much pressure on the pencil. For a mechanical pencil, use a 0.5 mm lead.

As the image develops, thicken silhouette and contour lines.

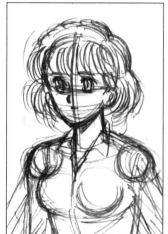

As the image develops, thicken silhouette and contour lines. The advantage of a mechanical pencil is that it draws evenly distributed, fine lines regardless of the pressure applied. In contrast, a regular pencil enables you to modulate the thickness and darkness of your strokes according to the pressure you apply. A mechanical pencil helps when drawing detailed areas or small compositions and a regular pencil helps when drawing large compositions. Match your drawing tools to your needs.

Use 2B and 3B leads for large compositions.

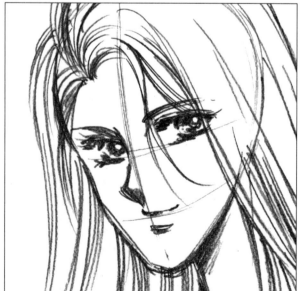

Pencil holds the advantage of allowing you to draw on a large format comfortably.

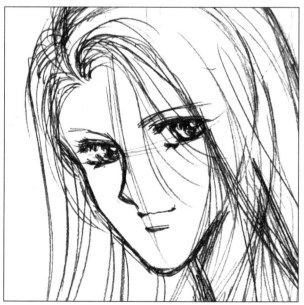

Mechanical pencils struggle with long strokes, even with 0.5 or 0.7 mm points, making them unsuited to large formats.

Note: An 0.3 mm mechanical pencil is suited toward detailed drawing. When sketching, avoid using too light a touch or the drawing will appear limp and lifeless.

Feel free to use different pencils for different parts

There is a reason that so many strokes are used in the under drawing. This is because it allows you to select which strokes are the best when inking. Therefore, there is no need for you to use single, clean lines at the under drawing stage.

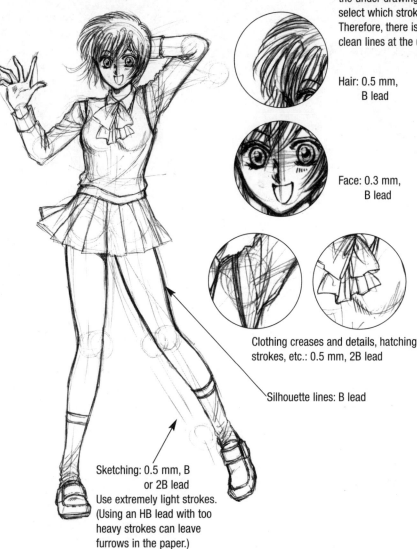

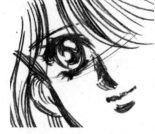

Hair: 0.5 mm,
B lead

Face: 0.3 mm,
B lead

Use a soft B or 2B lead for skin and other soft areas.

Clothing creases and details, hatching strokes, etc.: 0.5 mm, 2B lead

Silhouette lines: B lead

Use a hard H or F lead for rocks and other hard objects.

Sketching: 0.5 mm, B
or 2B lead
Use extremely light strokes.
(Using an HB lead with too
heavy strokes can leave
furrows in the paper.)

Use a regular or mechanical pencil first when practicing special effects.

When practicing hatching, radiating lines (burst effect), or other such special effect often used in *manga*, start with a pencil rather than jumping in with a pen. Once you become proficient at drawing with a pencil, you will come to understand the tricks to drawing in pen.

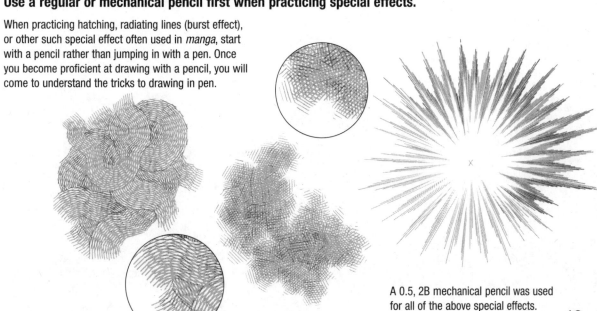

A 0.5, 2B mechanical pencil was used for all of the above special effects.

Pencils Used for Under Drawings

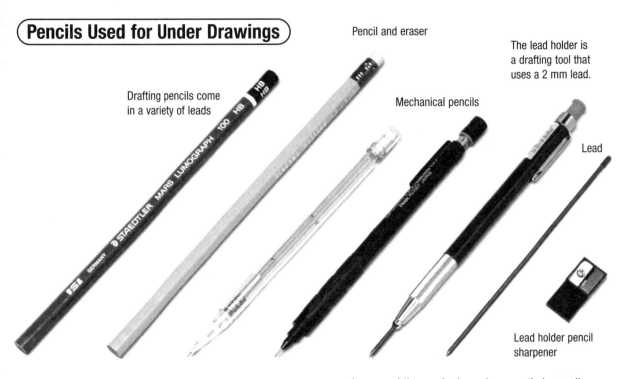

Drafting pencils come in a variety of leads

Pencil and eraser

Mechanical pencils

The lead holder is a drafting tool that uses a 2 mm lead.

Lead

Lead holder pencil sharpener

In general those who bear down on their pencils should use hard leads (HB, etc.), while those with soft touches should use softer leads (B, 2B, etc.).

● Drafting pencils

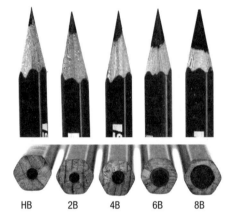

HB 2B 4B 6B 8B

● Mechanical pencil leads

2 mm lead holder lead

● Differences owing to lead hardness

Pencil

HB

2B

8B

Mechanical pencil

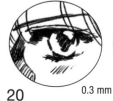

0.3 mm

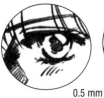

0.5 mm

0.7 mm

● Erasers

Rubber erasers Vinyl erasers

Vinyl erasers work well on typical mechanical pencils and HB lead pencils, while rubber erasers work well on 4B, 6B and other soft, dark leads.

If a vinyl eraser becomes soiled, be sure to wash and dry it properly. The eraser may be cut into smaller pieces for use with detailed areas. Avoid getting rubber erasers wet.

Chapter 2

Drawing Faces

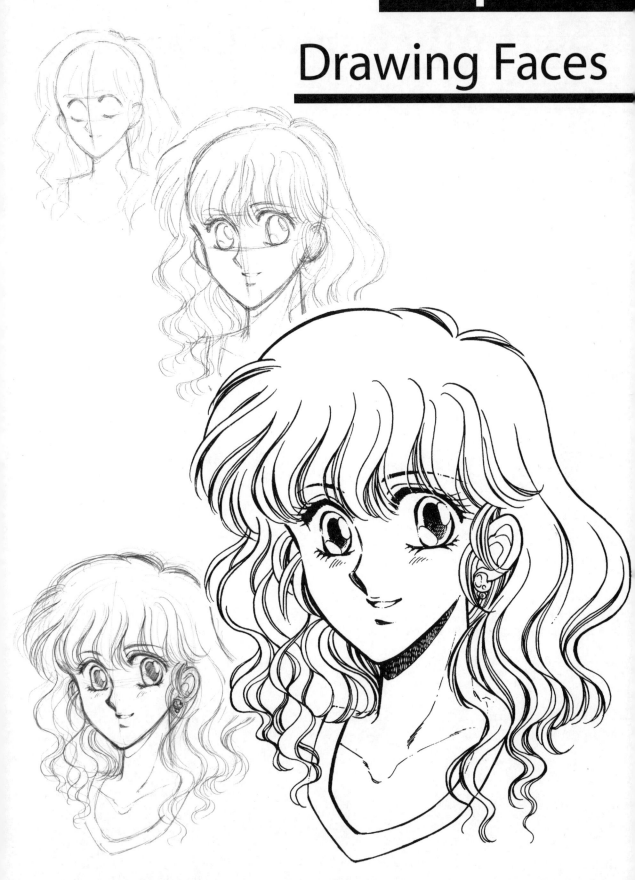

Faces: Start with a Rough Sketch.

The Head Is Oval

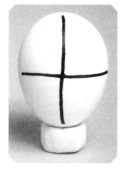

In a frontal view, the eyes are almost at the head's center.

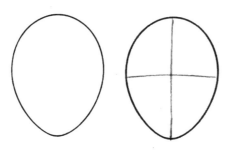

Draw an oval and then an X. This constitutes the face's most basic layout.

Start with an oval and then draw an X across it. This forms the most basic layout of the human face. Since these lines are crucial and constitute guidelines for drawing the eyes and nose to ensure their positions are well balanced, use a straightedge to draw them until you become more proficient.

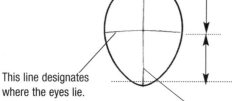

This line designates where the eyes lie. The human face is a relatively flat curved surface, upon which the eyes and nose rest. Use a downward curve when the face is looking down and an upward curve when the face is looking up.

This line, the center line, connects the crown to the chin in a straight line and denotes in which direction the head faces.

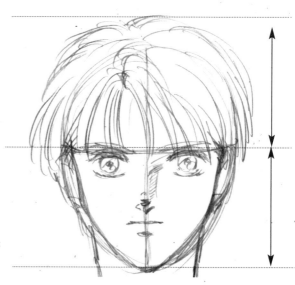

Using an egg with an X drawn across it will help you capture the sense of a specific direction being faced and a sense of volume.

Simply drawing an X across an egg will let you know how the face appears when facing various directions.

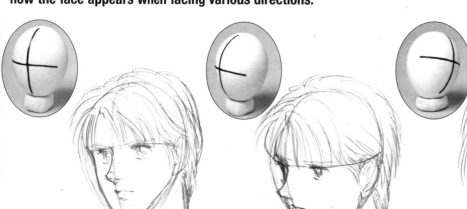

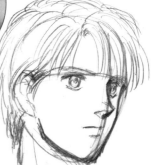

22

The head remains egg-shaped, whether facing frontward or sideways.

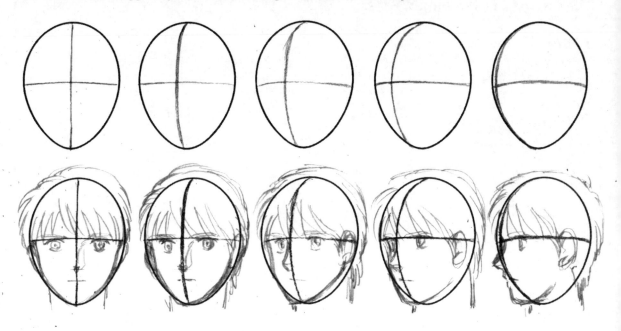

The X should arc in the direction the head faces.

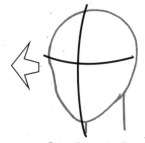

Draw the center line to connect the base of the nose with the chin.

The nose is always just outside the vertical line.

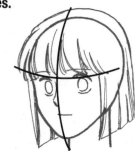

There are four ways of determining the eyes' placement using the horizontal line.

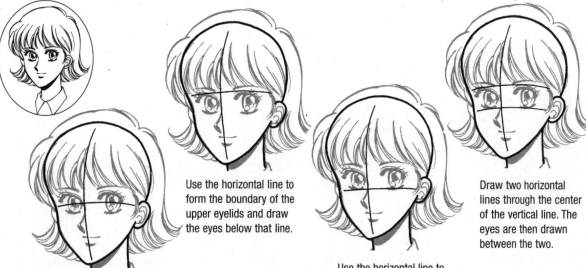

Draw the eyes centered along the horizontal line.

Use the horizontal line to form the boundary of the upper eyelids and draw the eyes below that line.

Use the horizontal line to denote the boundary of the lower eyelids and draw the eyes above that line.

Draw two horizontal lines through the center of the vertical line. The eyes are then drawn between the two.

23

Five Pointers in Drawing a Face

1. The Facial Features

From the front, the eyes lie apart about the distance of an eye.

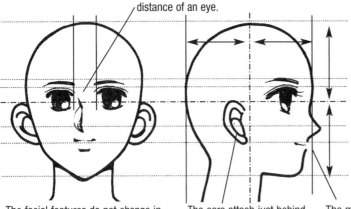

The facial features do not change in height whether seen from the front or side.

The ears attach just behind center.

The mouth lies in farther than the forehead.

2. The Shape of the Head

The human head appears to be almost a circle whether viewed from the front or side, so use a circle for abstracted heads or for sketching the basic layout.

3. The Ears

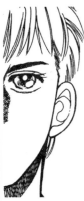

Standard

Large (sticky-out) ears

The ears lie along the side of the head.

No matter the size, the ears' base are the same length, and they attach at the same spot.

4. The Neck

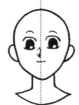

The neck is centered in the front view.

Good **Not good**

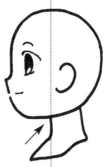

The neck is just behind center and angled in the side view.

5. Back of the Head (Side View)

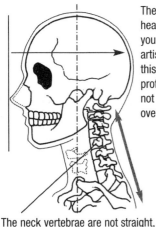

The back of the head is larger than you might think, and artists tend to forget this when drawing profiles. Take care not to draw the head overly compressed.

The neck vertebrae are not straight, but attached at an angle.

Good

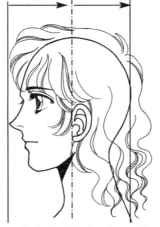

Draw the back of the head about the same width as the distance from the tip of the nose to the base of the ears.

Not good

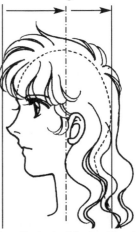

Here, the back of the head has been overly compressed. Despite the face having been carefully drawn, the poor resulting balance ruins the head.

Building up the Head

Frontal View
Plot the positions of the facial features and draw the face's silhouette line.

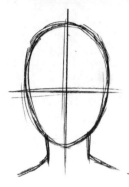 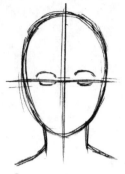

At this point, all that you need to determine is the eyes' position, so just mark them down as circles.

① Draw an X through an oval (or circle). Next, sketch where the eyes will lie.

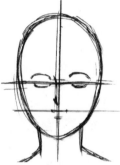 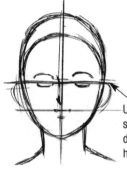

Use the hairline's side points to determine the eyes' height.

② Sketch in the mouth after you have determined where the nose will lie.

③ Mark down the ears and hairline. Sketch in the ears after you have determined where the eyes and mouth will lie.

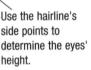

④ The head's silhouette line becomes finalized once all of the other facial features have been plotted.

Sketch the hair.

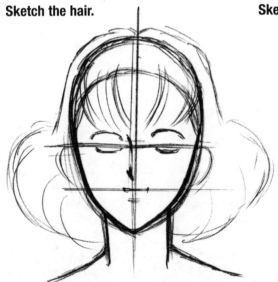

Add the hair once you have determined the face's shape.

Sketch the facial features.

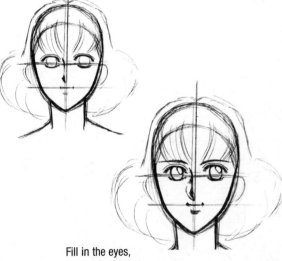

Fill in the eyes, nose, mouth, and eyebrows.

Add the finishing touches—eye and ear details.

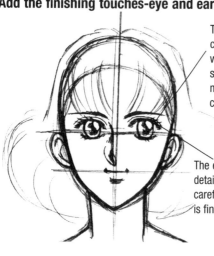

The pupils end up as a contrast between black and white light reflections: they should be drawn once the majority of the face has been completed.

The eyelashes are a finely detailed feature: draw them carefully after everything else is finished.

Draw the hair.

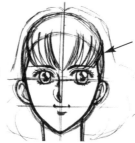
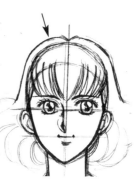

Start with the bangs, which are close to the eyes and eyebrows. Finish with the hair's silhouette line.

Completed under drawing

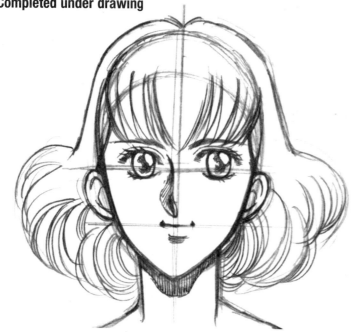

When rendering the hair in lines, draw the way the hair flows in detail.

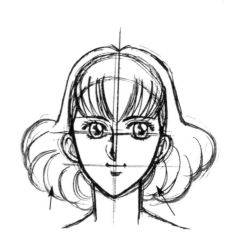

When rendering the hair in solid black, detailed lines are not necessary.

Tricks to Drawing a Frontal View—When You Just Can't Get the Right and Left to Balance

Right

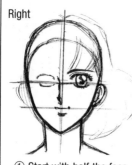

① Start with half the face.

Left

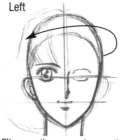

② Flip over the paper, lay another sheet of paper on top, and trace.

Left

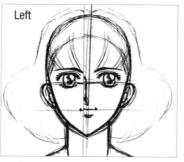

③ Match up the two sheets of paper.

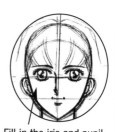

Fill in the iris and pupil after having matched up the two sides.

26

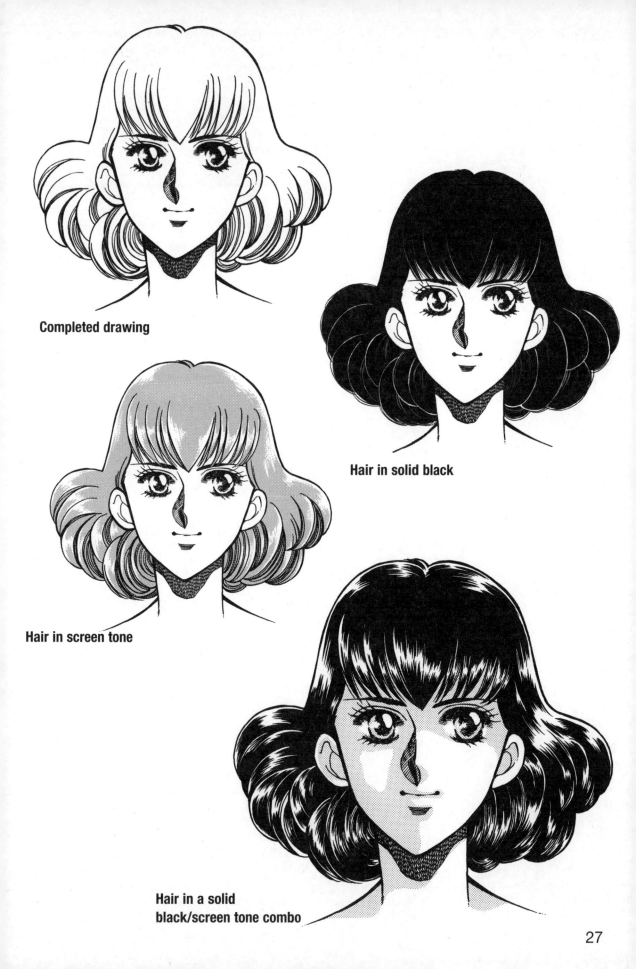

Completed drawing

Hair in solid black

Hair in screen tone

Hair in a solid
black/screen tone combo

3/4 View

Plot the basic layout and silhouette lines and sketch in the bridge of the nose.

First, sketch the nose and half of the face (here, the left side). Next, sketch the second half balancing it with the first. I recommend that those of you who are left handed start with the right side of the face.

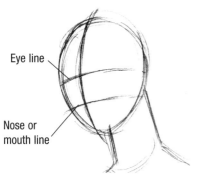

Eye line

Nose or mouth line

Draw the general shape of the head and an X over that.

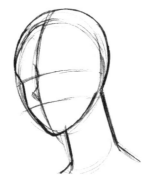

Decide first the proximate silhouette lines of the face and head. Sketch in the bridge of the nose, even if you do not plan to include it in the final image.

Draw the right eye, the nose, and the mouth.

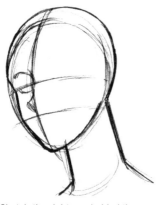

Sketch the right eye behind the nose.

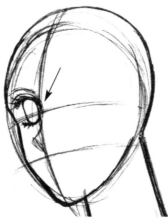

Take care that the corner of the eye does not interrupt the bridge of the nose.

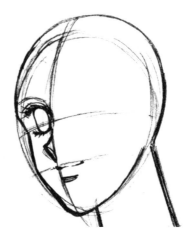

Draw the left eye and sketch in the hairline and the ear.

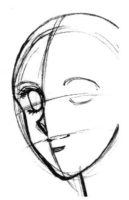

Take care to balance the left eye with the previously drawn right eye.

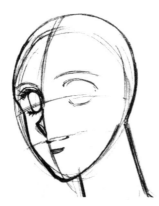

Proportions should be easier to balance if you determine the eye's shape before drawing the eyebrow.

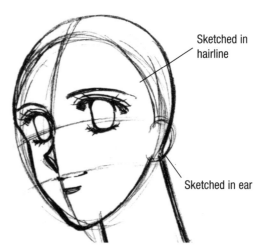

Sketched in hairline

Sketched in ear

As with the frontal view, start with the central features, gradually moving outward.

Draw the ears and the hair.

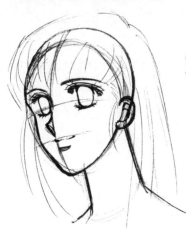

Start with the bangs, side wisps, and any other portion actually touching the face.

Since the ear affects how the hair flows, draw it relatively thoroughly before drawing the hair.

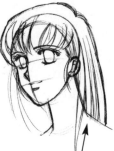

Next, draw the wide tresses of hair to the right.

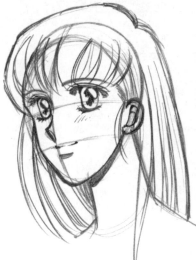

Draw the far tress of hair, matching it with the near side. Lastly, add fine flow lines to finish.

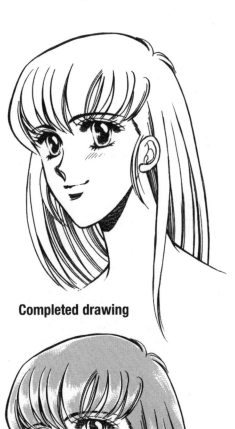

Completed drawing

Hair in screen tone

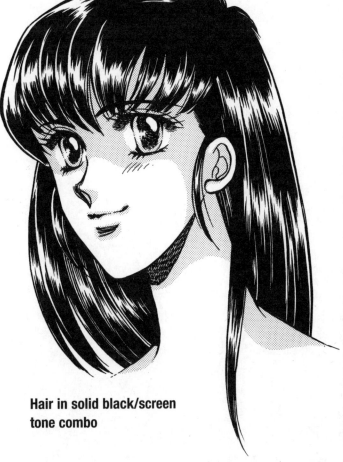

Hair in solid black/screen tone combo

Side View
Draw the silhouette lines.

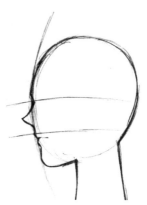

Sketch the basic layout of the head. Note that the neck's angle and head's shape should be different from when seen from the front.

Here, we see the basic layout of the eye and nose. For side views, it is especially important to establish the positions of not only the eye but also of the bottom of the nose (or the mouth).

Draw the side silhouette of the entire head, including the face.

Sketch the eye, eyebrow, ear, and hairline.

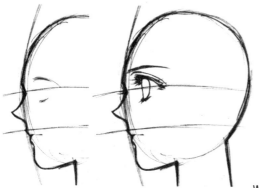

Layout for the eye

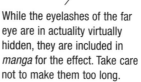

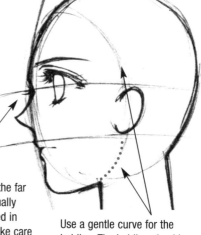

While the eyelashes of the far eye are in actuality virtually hidden, they are included in *manga* for the effect. Take care not to make them too long.

Use a gentle curve for the hairline. The hairline should appear naturally to run from the jaw to the ear.

Draw the hair

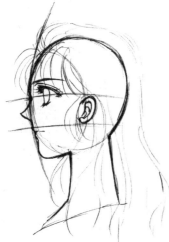

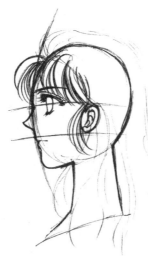

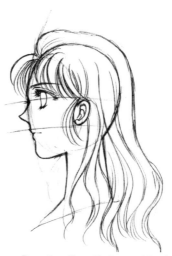

Draw the ear. Sketch the general layout of the hair.

Draw the bangs and side wisps.

Draw the silhouette line and flowing internal lines.

Add the finishing touches.

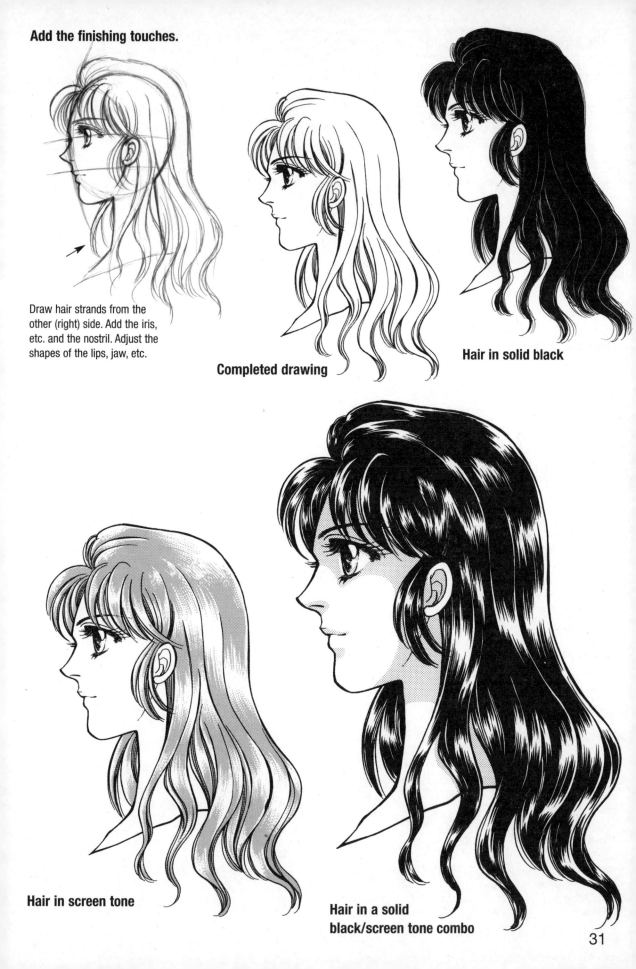

Draw hair strands from the other (right) side. Add the iris, etc. and the nostril. Adjust the shapes of the lips, jaw, etc.

Completed drawing

Hair in solid black

Hair in screen tone

Hair in a solid black/screen tone combo

31

Making Practical Use of the Basic Layout

Lines used in the basic layout serve as guides for positioning the eyes, nose, and mouth on an ovoid solid; hence, these lines should be curved. Good use of these guidelines will allow you to draw a 3-dimensional face.

Always use curved lines for the basic layout.

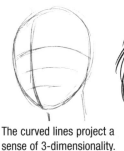
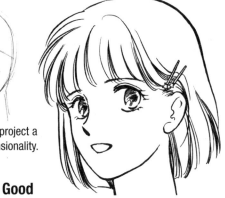

The curved lines project a sense of 3-dimensionality.

Good

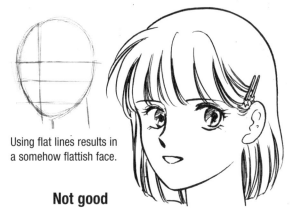

Using flat lines results in a somehow flattish face.

Not good

The basic layout makes any angle possible.

Here is a face seen from a somewhat high angle. Since the top of the head is visible, draw the vertical guideline first crossing the front and then the top of the head. The horizontal lines assume a downward curve in angles where the top of the head is visible.

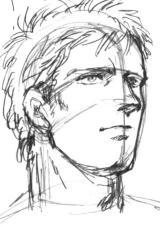

Here we see a somewhat low angle. The horizontal lines, which function as guidelines for the eyes and nose, take on an upward curve.

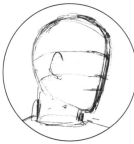

Here we have a face looking downward and seen in full profile. The horizontal lines drawn almost completely straight create the feeling of a total side view. Angling the vertical line results in a head facing downward.

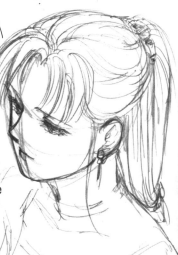

Here is a face seen from a downward looking, oblique angle. The vertical line serves to indicate where the face is directed as well as a guideline for how much volume to give the head.

32

What happens when the basic layout is ignored. — The fundamentals of basic layouts

The vertical guideline is the key to drawing the head's silhouette line.

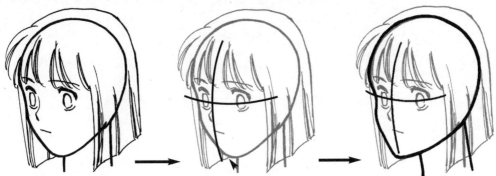

Here, despite that the features are shifted to the side, the silhouette line suggests a normally angled face.

Using a gently curving line to connect where the nose attaches to the face to the nose's bottom reveals that the chin needs to be shifted more to the left.

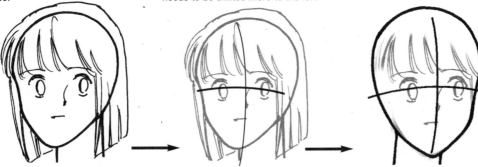

Here, despite that the features are shifted to the right, the silhouette line suggests the head is facing left.

The horizontal lines align the eyes. The vertical line ensures the nose and mouth are centered on the face.

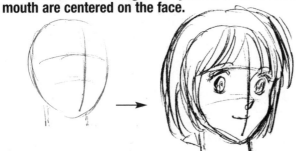

Face drawn with guidelines

Face drawn without guidelines

Good

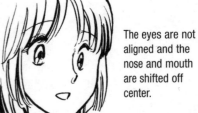

Not good

The eyes are not aligned and the nose and mouth are shifted off center.

Distinguish between long and round faces.

Modifying distances between facial features allows you easily to create different character types.

Basic layout of a long face

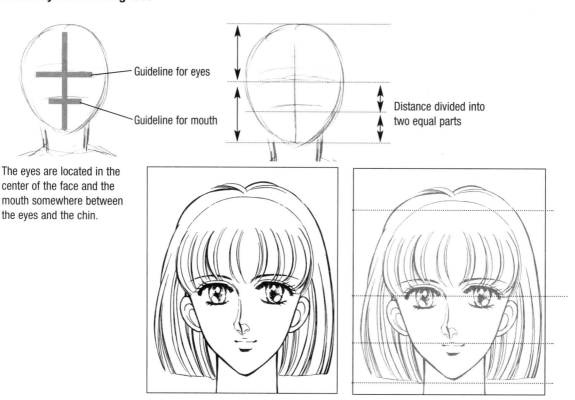

- Guideline for eyes
- Guideline for mouth

Distance divided into two equal parts

The eyes are located in the center of the face and the mouth somewhere between the eyes and the chin.

Basic layout of a round face

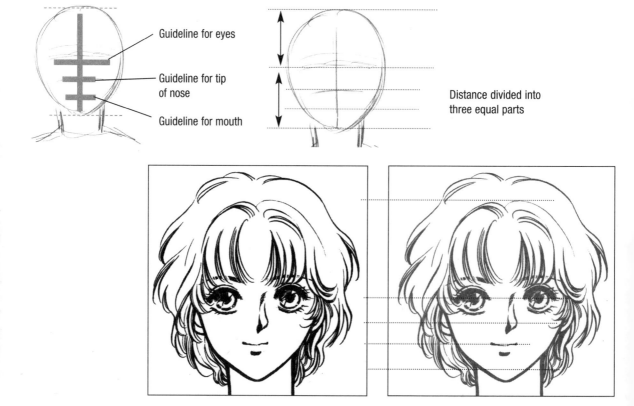

- Guideline for eyes
- Guideline for tip of nose
- Guideline for mouth

Distance divided into three equal parts

Frame the composition neatly.

A sheet of paper has physical limits. Keeping the composition's dimensions in mind should help you successfully frame it. Plot the head's basic layout maintaining consideration for the final size.

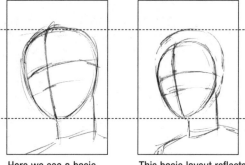

Practice drawing this head.

Here we see a basic layout without consideration shown to the hair's volume.

This basic layout reflects the hair's volume.

Try using a basic layout when drawing within a postcard frame.

Basic layout for the head alone

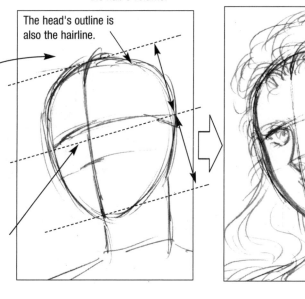

The head's outline is also the hairline.

The hair has not been included in the basic layout.

The eyes are located north of center.

The face is large and has impact, but the hair is cut out of the frame.

Basic layout including the hair

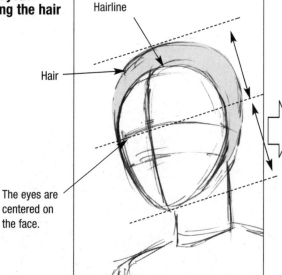

Hairline

Hair

The eyes are centered on the face.

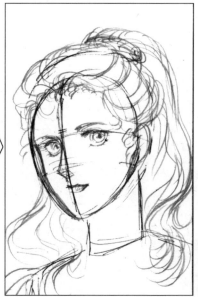

The hair fits within the composition's frame.

35

Make the different characters' ages distinct.

Childlike or chibi characters

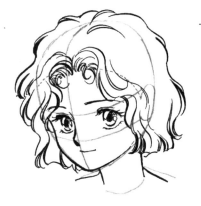

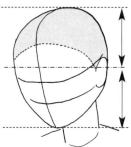

The eyes are located just south of center (to make the head appear larger).

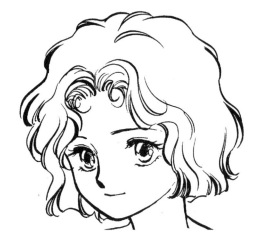

Standard or shojo (girl) characters

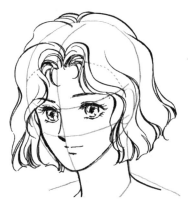

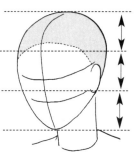

The hair constitutes 1/3 of the total head.

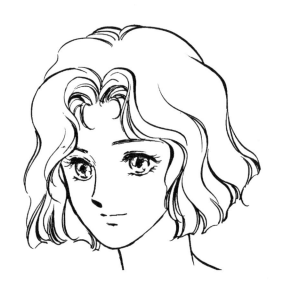

Realistic or adult characters

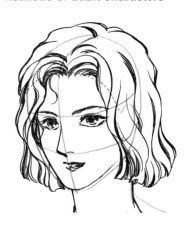

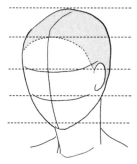

The hair constitutes 1/4 of the total head.

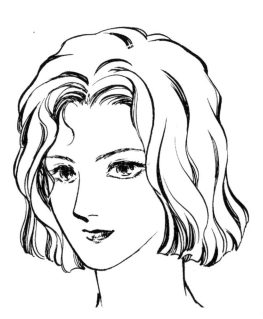

Drawing a Face from a Snapshot

Reference photo

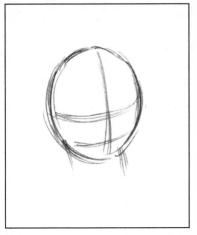

① Draw an X across an oval to establish the direction faced.

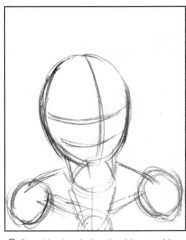

② Roughly sketch the shoulders and hand.

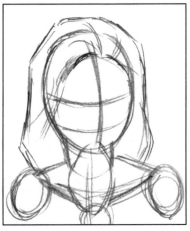

③ Add the hairline and space allotted for the hair.

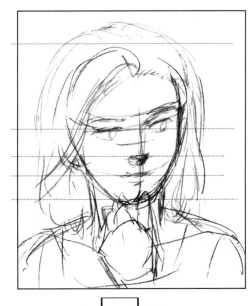

④ Sketch in the eyes, nose, and mouth.

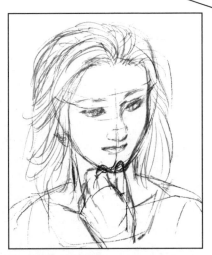

⑤—A Realistic Style
Use dark lines for the eyes' contours and draw the bridge of the nose faithfully.

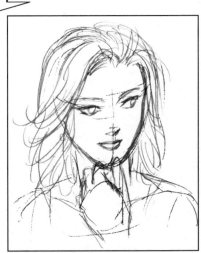

⑤—B *Manga* Style
The eyes and nose are abstracted.

Designing Faces From Profile Views

There are occasions where the profile and frontal view of the face will seem to be from 2 different characters. Here, we look at composing a front view from a target profile.

Take careful note of how much the nose projects from the face in both the profile and frontal views.

Beautiful woman with a defined nose

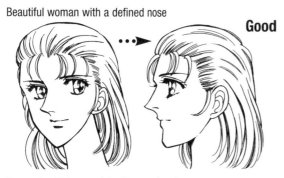

Good

Cutie with a button nose

Good

Noses should be consistently prominent from both the front and profile.

Not good

Regardless of whether the hairstyle and eyes are the same, with a button nose this becomes a different character.

If a character with a button nose is given a defined nose in the profile view, then she becomes a different character.

Not good

Facial feature placement

Artists often find when they draw lines through the two views that the faces do not match up. Try this once for the sake of taking control over your own style.

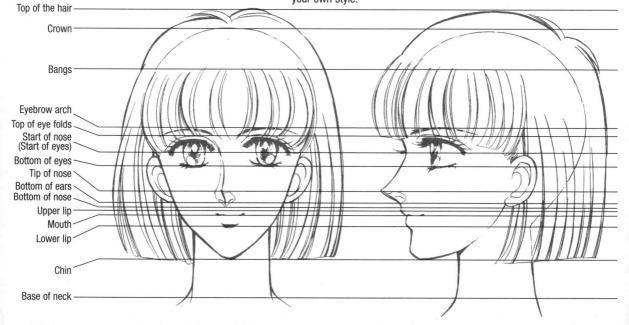

Top of the hair
Crown
Bangs
Eyebrow arch
Top of eye folds
Start of nose
(Start of eyes)
Bottom of eyes
Tip of nose
Bottom of ears
Bottom of nose
Upper lip
Mouth
Lower lip
Chin
Base of neck

Draw guidelines, matching the eyes, noses, and mouths while drawing.

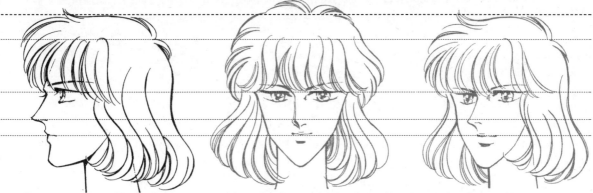

① **Adult Faces**
Design the nose, eyes, and mouth to have "adult" attributes. Use almond-shaped eyes with small, black pupils and irises, straight noses, and smallish mouths to suggest a mature face. Nostrils may be included.

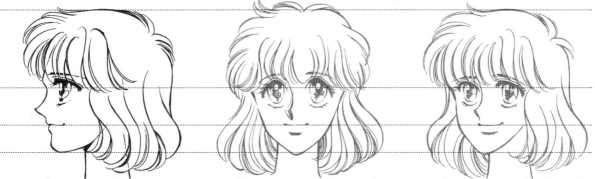

② **Shounen (Boy) and Shoujo Faces—1**
Having the bridge of the nose arc and slightly rounding the chin and lips creates the look of a young girl or boy. Drawing the eyes taller than wide, adding large irises and pupils, and tilting the eyebrows downward results in a charming young girl's face. This type of face has an eyelid fold line.

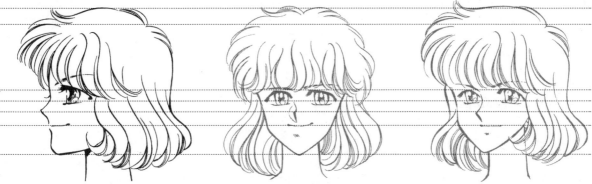

③ **Shounen and Shoujo Faces—2**
Drawing the bridge of the nose as a short, straight line and making the chin pointed creates a harder-looking character. Thickening the eyebrows and adjusting the hairstyle results in a boy character. Enlarging the irises and giving the eyes a moderate downward slant produces a tomboy.

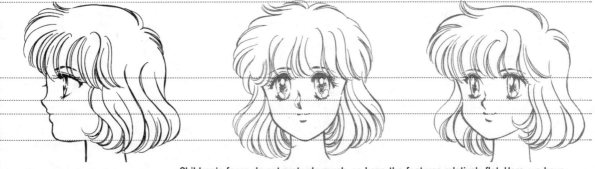

④ **Child Faces**
Children's faces do not protrude much, so keep the features relatively flat. Here, we have a tiny button nose and no prominent bridge. The eyes occupy about 1/2 of the face.

Four Profile Types

The differences between profiles lie primarily in the nose. Since the nose is used to distinguish the character's age (e.g. a grown up, a child, etc.), a distinction is made in the facial features according to the character's supposed age.

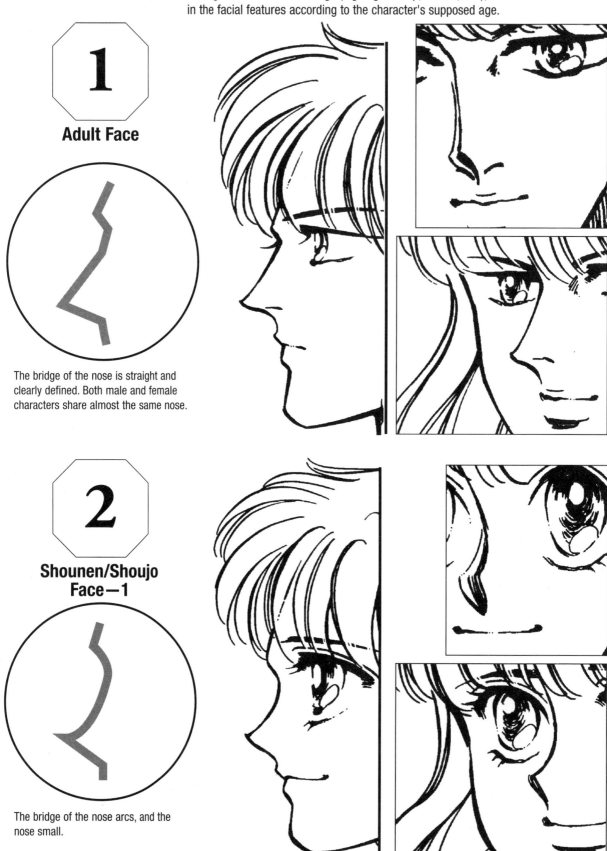

1

Adult Face

The bridge of the nose is straight and clearly defined. Both male and female characters share almost the same nose.

2

Shounen/Shoujo Face—1

The bridge of the nose arcs, and the nose small.

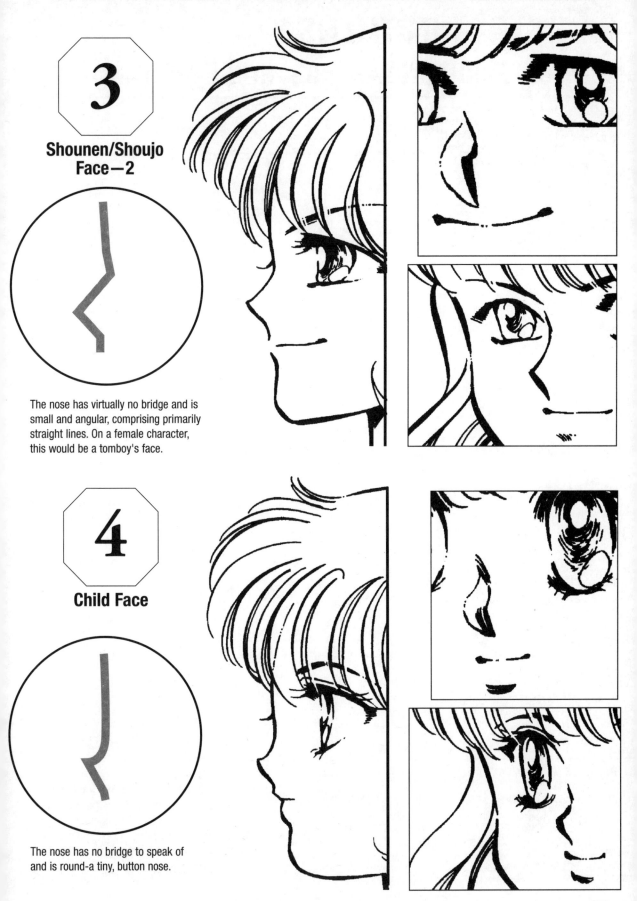

3

Shounen/Shoujo Face—2

The nose has virtually no bridge and is small and angular, comprising primarily straight lines. On a female character, this would be a tomboy's face.

4

Child Face

The nose has no bridge to speak of and is round-a tiny, button nose.

Facial Features
(Eyes, Mouth, Nose, Ears, and Eyebrows)

The Basics of the Eyes

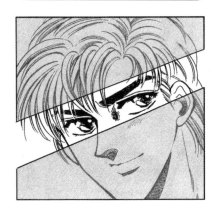

Eyelid fold

Inside corner

Eyelid

Upper eyelash

Light reflection

In *manga* and anime, the corner of the eye is often rendered unconnected.

Iris

Including this wrinkle is guaranteed to age any character.

Sclera (white)

Pupil

In *manga*, the lower eyelid is usually rendered with a single line.

The most favored eye shape is almond.

① Draw the upper eyelid.

② Draw the lower eyelid.

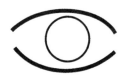

③ Draw a circle for the iris, and presto! An eye!

Assorted Shapes

Leaving both corners unconnected results in a more *manga*-esque eye.

Modifying the distances and curves of the upper and lower eyelids produces a multitude of eye shapes.

Eye with the upper eyelid accentuated

Eyelids

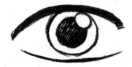

Here, a single line was used for the eyelid.

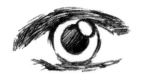

Here, multiple, sketchy strokes were used.

The eye is the most important facial feature when drawing a character. Gives the character a sense of presence and projects an impression of his or her personality. In *manga*, the eye can be considered the most difficult as well as the most crucial feature.

The Basics in Iris Size

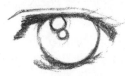 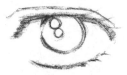 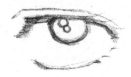

Here, the iris and the lower eyelid are touching. This is suited to children and innocent characters.

This is the standard iris size. The iris occupies half or more of the total height.

Here, the iris is small, only occupying less than half of the total height. This is suited to adults and villains.

Assorted Stylized Eyes

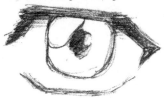 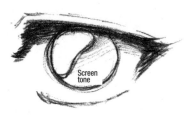 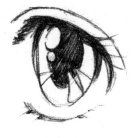

This eye features a squarish iris and is sans eyelashes. Contour lines are straight.

Here, the upper eyelid is thick, and a large light reflection occupies the pupilless eye.

This tall iris features compound light reflections.

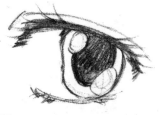 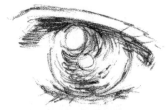 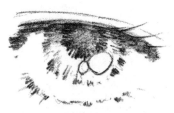

This eye sports an enormous pupil, an oddly shaped iris, and long eyelashes.

Here, the entire iris has been rendered using sketchy strokes. Shading also defines spots of reflected light.

Here, radiating strokes were used to render the iris and delicate hatching, the lower eyelid.

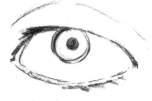 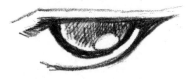 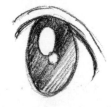

This basic, smallish iris has been drawn without light reflections. The eyelid's contour lines have been rendered simply, producing a realistic effect.

Here is a squinted eye, where the corners have been emphasized. Extra thick strokes were used for the iris's outline, and cross-hatching was used for the inside.

The lower eyelid was omitted on this eye. Instead, only light reflections were added to the iris.

Creating Anime-esque Eyes

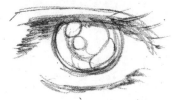 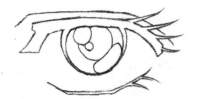

① Use clear, solid lines for contour lines, outlines, and the eyelashes.

② Fill in the contour lines and outlines with ink.

Masculine Eyes

Frontal View

Characteristics of masculine eyes

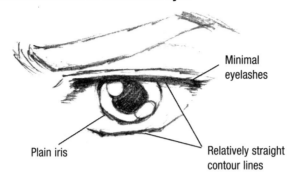

Minimal eyelashes

Relatively straight contour lines

Plain iris

Drawing Steps

① Start with the contour lines, using relatively straight strokes.

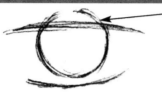

Include that portion covered by the upper eyelid.

② Sketch an outline of the iris.

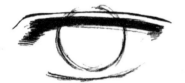

③ Draw the upper eyelid and the fold line.

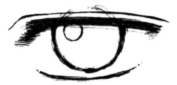

④ Draw the lower eyelid and the main light reflection.

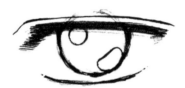

⑤ Add an extra light reflection.

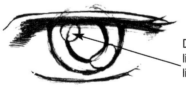

Do not darken any lines falling inside of light reflections.

⑥ Draw the pupil and eyelashes.

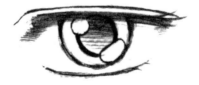

⑦ Finished!

The lower eyelid determines the eye's shape, so take care in rendering them.

Not good

Not good

Mismatched eyelids

Good

When designing the lower eyelid, try drawing a dotted line and connecting it with the upper.

Side View

 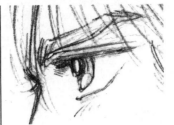

The steps to drawing are almost the same as with frontal views.

Take care with the iris's size.

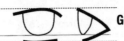 **Good**

Not good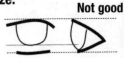

The iris and lower eyelid are not touching.

Here, the irises in the front and side views are different sizes.

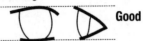 **Good**

The iris and lower eyelid are touching.

Drawing Steps

 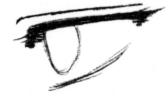 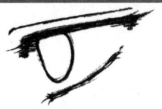

① Draw the contour lines.

② Draw the upper eyelid and fold. Sketch in the iris.

③ Draw the iris and the lower eyelid.

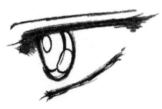 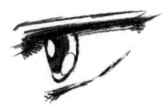

④ Add light reflections and the pupil to finish. If you draw two light reflections in the front view, be sure to also include them in the side view.

⑤ Here we see an under drawing that is pretty close to how the inked drawing will appear.

Gazing Downward

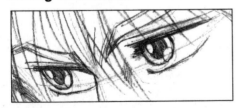

When the character is looking downward, the upper eyelid should swell in a downward direction, so take extra care when drawing.

Drawing Steps

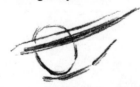 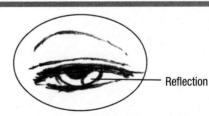

① The basic layout-the eyelid is lowered, so draw the exposed area of the iris as if more covered than usual.

② The completed under drawing-light reflects off the iris and should be included even if the iris is more abbreviated than usual.

Reflection

Here, the iris is covered to the extent that light just barely reflects off the eye.

45

Feminine Eyes

Frontal View

Characteristics of Feminine Eyes

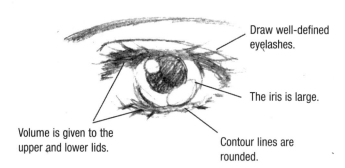

Draw well-defined eyelashes.

The iris is large.

Volume is given to the upper and lower lids.

Contour lines are rounded.

Drawing Steps

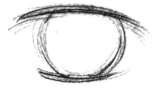

① Sketch the basic layout. Use larger, plumper eyebrows and iris than you would for a masculine eye.

② Use small, delicate strokes to build up the eyelid and iris.

③ Stress light and shadow by darkening the center of the eyelid contour, while lightening the corners.

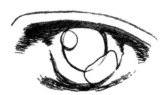

④ Make the iris larger than you would for a masculine eye. The light reflections should likewise be larger.

⑤ Add the eyelashes to finish.

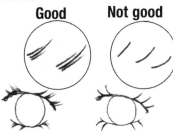

Good **Not good**

Do not draw the eyelashes individually but in clusters. This will produce a more pleasing image.

Side Views and Gazing Upward

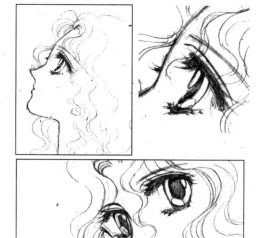

 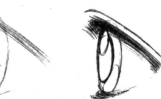 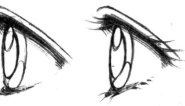

Follow the same drawing steps:
basic layout → contours and outlines → the iris and pupil → reflected light → the eyelashes

 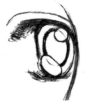 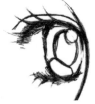

46

Rendering the Eyes and Movement

Methods of Rendering Distinct to the Iris

Eye 1

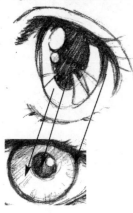

① The basic layout

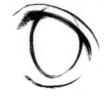

② Contours and outlines

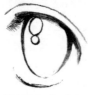

③ Light reflections

Adding delicate hatching to the corner of the upper eye produces a glistening, moist effect.

Here we see common light reflections and reflections of the surrounding environment rendered as triangles and other geometric shapes.

For the triangular reflections, use curved lines that follow the iris's rounded surface.

④ Add triangular reflections.

⑤ Draw the iris to finish.

You may add more eyelashes than shown here.

Eye 2

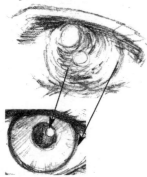

① Basic layout

② Outlines and contour lines

Do not define the outline of the iris and light reflection too strongly, but simply sketch them lightly.

Use delicate, sketchy strokes in pen for the entire interior of the iris. The key is to sketch roughly first any light reflections.

Make sure the reflection's surrounding area is solidly filled in, using strokes that build outward.

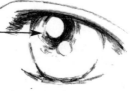

③ Build up the hatching from the eyelid.

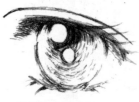

④ Fill in with delicate strokes, leaving light reflection white.

Eye 3

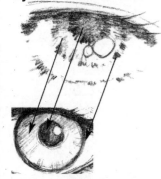

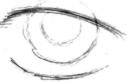

① Basic layout

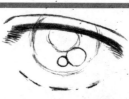

② Outlines and contours

Draw the light reflections' outlines using bolder lines than you used for the pupil's.

Feel free to add extra lines radiating from the iris's center.

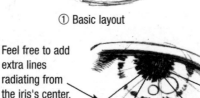

③ Draw the iris and the pupil.

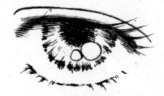

④ Completed drawing

Here is a rather realistic drawing. Radiating strokes were used for the iris and eyelids.

47

Using Light Reflections to Reinforce the Direction of the Gaze

Side reflections

Add a light reflection just right or left of or diagonally above or below center.

Adding a small reflection opposite a large reflection suggests 2 opposing light sources (a small and large).

The character is gazing off to the left (from the viewer's perspective).

A light reflection is drawn in the opposite direction of the character's gaze (the right side).

Reflections of light on the eyes indicate the direction of the character's gaze. There are 2 basic types: those located centrally on the iris and those to the right or left.

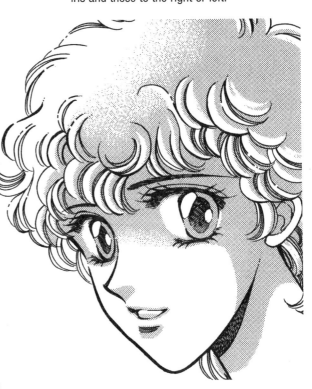

Here, the character is gazing at the viewer (i.e. to the right). The light reflection in the upper left of the iris creates this effect.

Central reflections

This is a light reflection drawn in almost the center of the iris.

The gaze is directed left.

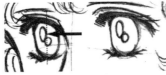

Draw a large light reflection on the same side as the gaze is directed (i.e. to the left).

Iris Movement in Upward Slanting and Drooping Eyes

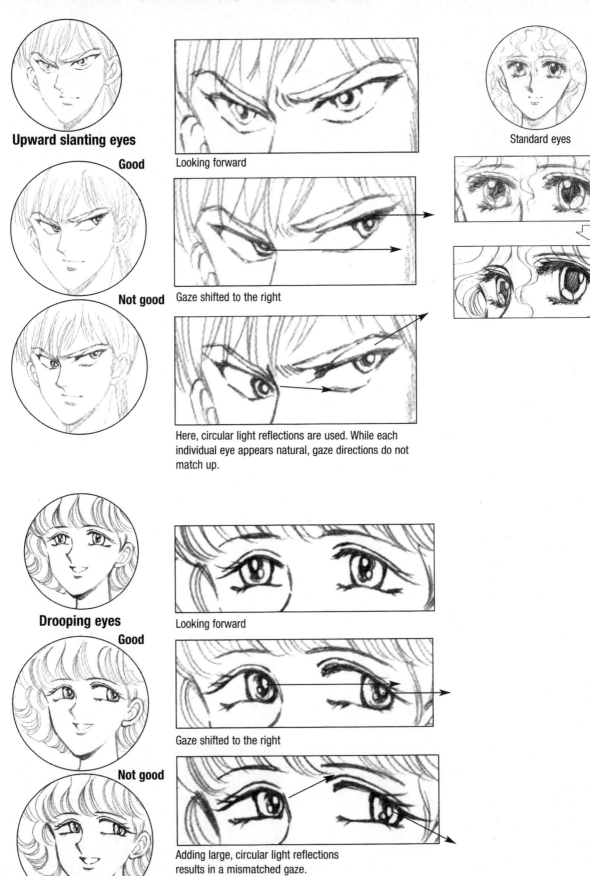

Upward slanting eyes

Good

Not good

Looking forward

Gaze shifted to the right

Here, circular light reflections are used. While each individual eye appears natural, gaze directions do not match up.

Standard eyes

Drooping eyes

Good

Not good

Looking forward

Gaze shifted to the right

Adding large, circular light reflections results in a mismatched gaze.

Four Common Mouth Types

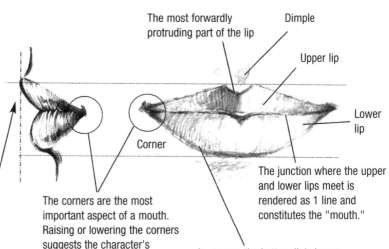

The most forwardly protruding part of the lip

Dimple

Upper lip

Lower lip

Corner

In a realistic drawing, the upper lip protrudes more than the lower.

The corners are the most important aspect of a mouth. Raising or lowering the corners suggests the character's personality or emotional state, establishing the viewer's impression.

The junction where the upper and lower lips meet is rendered as 1 line and constitutes the "mouth."

In *manga*, the bottom lip's lower contour is the most frequently manipulated feature for making the mouth expressive.

Mouths as a line

This mouth was rendered using a single line plus a shadow formed underneath the lower lip. The key feature of this style, which is the most popular mode for shonen *manga*, is that the lips have not been defined. Modifying the way the shadow under the lip is rendered will change the mouth's look.

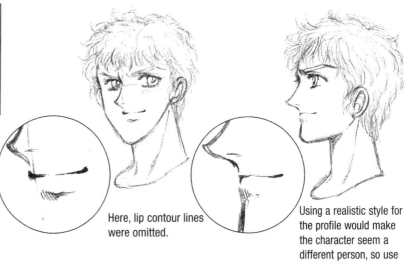

Here, lip contour lines were omitted.

Using a realistic style for the profile would make the character seem a different person, so use your ingenuity to avoid connecting lines.

Mouth with lower lip contours

Rather than opting for a monotonous single line for the whole mouth, here this line becomes an abbreviation of the upper lip. A gentle curve is then used to suggest the plumpness of the lower lip. This is not a realistic drawing employing meticulous detail.

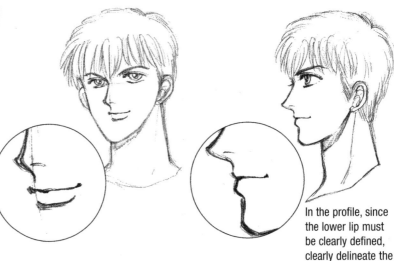

In the profile, since the lower lip must be clearly defined, clearly delineate the upper lip as well.

Fleshy, voluminous mouths

Here, we see a realistic depiction, emphasizing the lips' volume. The dimple above the Cupid's bow is suggested with a line.

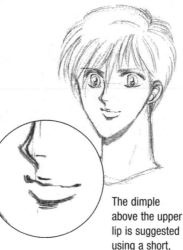

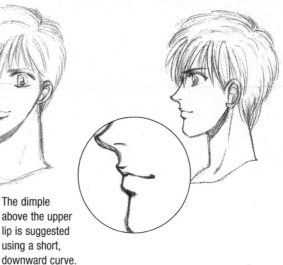

The dimple above the upper lip is suggested using a short, downward curve.

Lips in lipstick

Clearly delineate the upper and lower lips' contours. Since the composition is flat and all parts clearly visible, modulate lines and shapes used for the mouth's corners, the center, and the shadow for the lower lip.

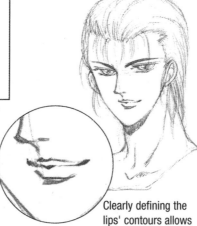

Clearly defining the lips' contours allows you to emphasize that the lower lip is plumper than the upper.

When drawing a profile, keep the lower lip line starting from the corner of the mouth short, cutting it off.

The mouth style indicates age in female characters.

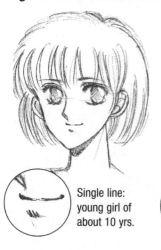

Single line: young girl of about 10 yrs.

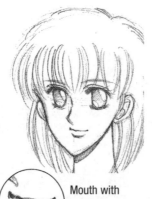

Mouth with lower lip contour: an adolescent girl of about 15 yrs.

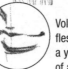

Voluminous, fleshy mouth: a young adult of about 20 yrs.

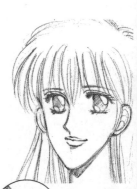

Mouth with lipstick: a young professional of about 25 yrs.

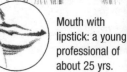

Three Common Nose Types

There is a depression where the bridge of the nose starts. When drawing the bridge, be sure to include this depression.

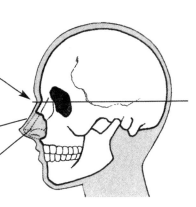

Bridge of the nose

The nose itself is not made of bone but of cartilage.

Manga-esque noses (no bridge)

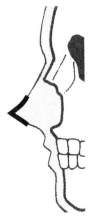

Here, only the tip has been drawn. The nostrils are usually omitted in this style.

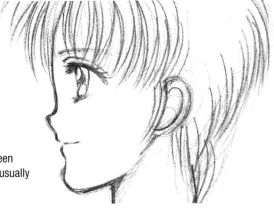

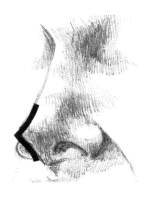

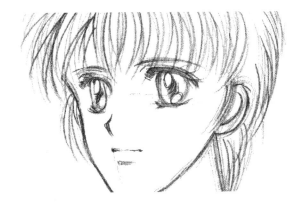

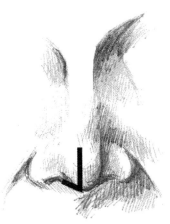

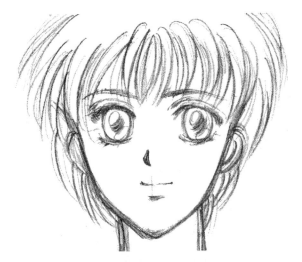

Realistic noses

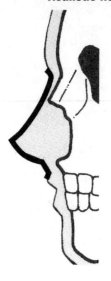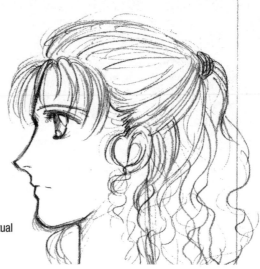

Use contour lines that are relatively faithful to an actual nose.

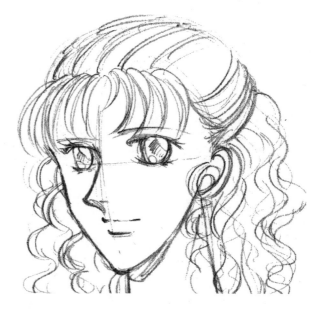

Omit the fleshy part of the nostril and this wrinkle.

This line indicates where the nose begins to swell.

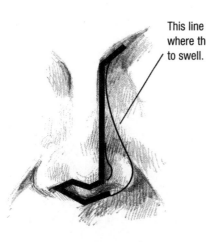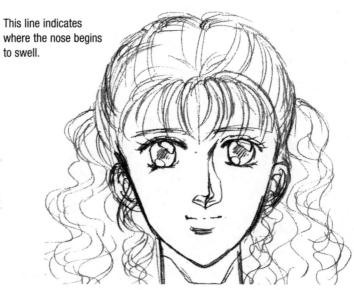

Somewhere between a *manga* and realism (intermediate style)

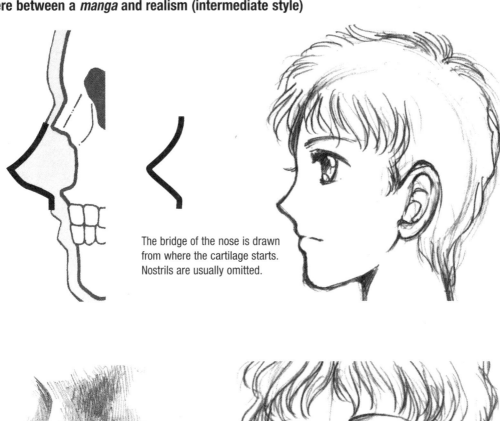

The bridge of the nose is drawn from where the cartilage starts. Nostrils are usually omitted.

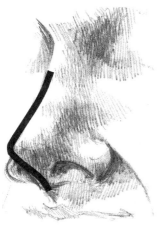

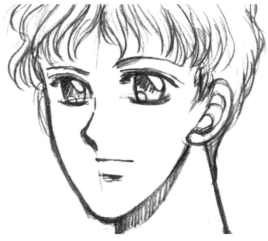

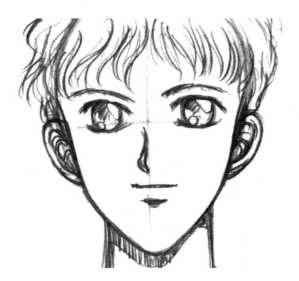

The bridge of the nose is defined using a contour lines not found on a real nose.

Sample realistic (aquiline) noses

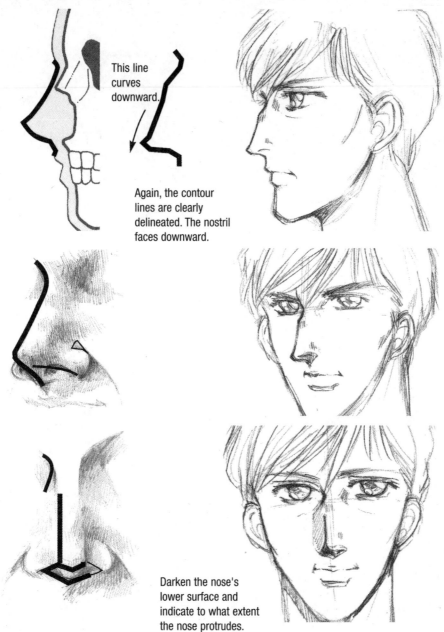

This line curves downward.

Again, the contour lines are clearly delineated. The nostril faces downward.

Darken the nose's lower surface and indicate to what extent the nose protrudes.

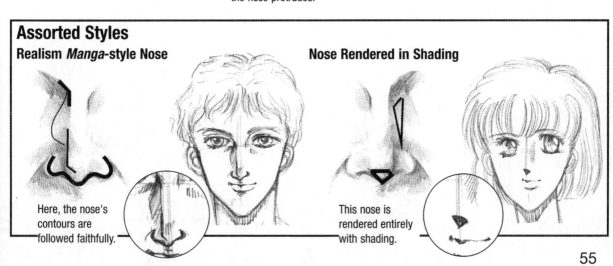

Assorted Styles

Realism *Manga*-style Nose

Here, the nose's contours are followed faithfully.

Nose Rendered in Shading

This nose is rendered entirely with shading.

Two Common Ear Types

The *manga* ear (the "6" ear) and
the realistic ear (the wave ear)

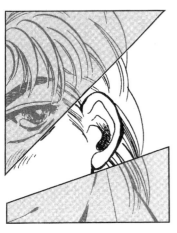

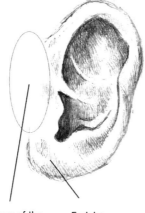

Base of the
auricle

Earlobe

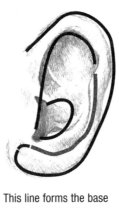

This line forms the base
of the ear's design.

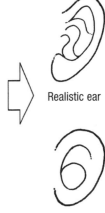

Realistic ear

Manga ear

Realistic ear

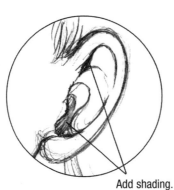

Add shading.

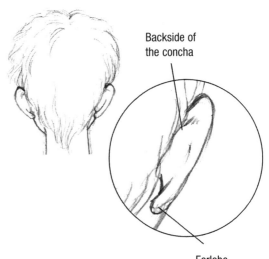

Backside of
the concha

Earlobe

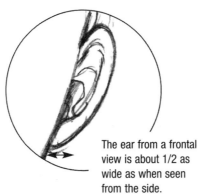

The ear from a frontal
view is about 1/2 as
wide as when seen
from the side.

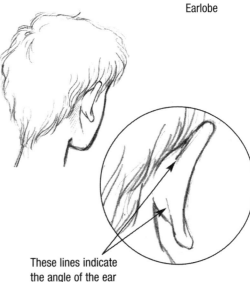

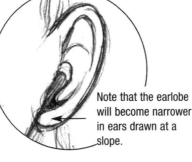

Note that the earlobe
will become narrower
in ears drawn at a
slope.

These lines indicate
the angle of the ear
and the thickness of
the helix (fold).

Manga ear

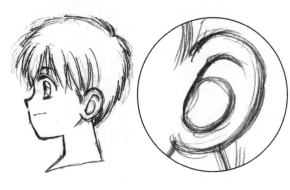

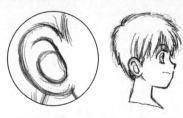

The *manga* ear consists of a "6" drawn within an oval. Take note that for the opposite ear, the image becomes reversed.

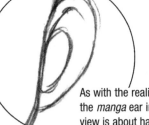

As with the realistic ear, the *manga* ear in a frontal view is about half the width as in profile. Use a tallish, 6-shaped whorl for the interior.

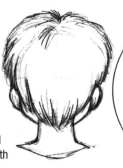

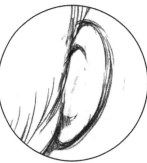

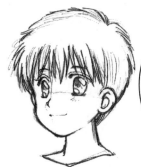

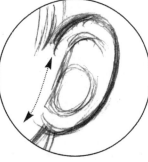

At an angle, the ear forms an oval. The curve of the auricle follows the jaw line.

Points of Consideration When Drawing the Ear
The ear appears to follow the side of the face.

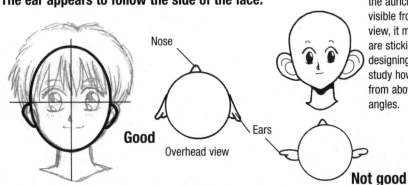

When the contents of the auricle are clearly visible from a frontal view, it means the ears are sticking out. When designing the ears, study how they look from above and other angles.

Earlobes

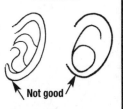

When drawing simplified ears, take care not to forget the earlobe, or your ears may not look like ears.

The Eyebrows as an Extension of the Bridge of the Nose

The eyebrow follows the brow ridge.

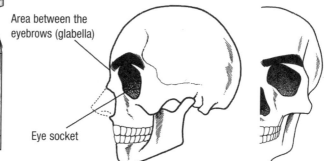

Area between the eyebrows (glabella)

Eye socket

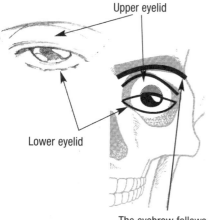

Upper eyelid

Lower eyelid

The eyebrow follows the brow ridge. Eyebrows come in various shapes and thicknesses.

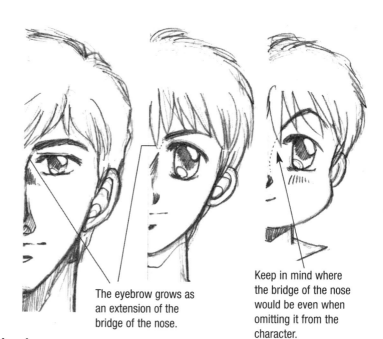

The eyebrow grows as an extension of the bridge of the nose.

Keep in mind where the bridge of the nose would be even when omitting it from the character.

Use the same distance eyebrow to forehead distance in the front view as in the profile.

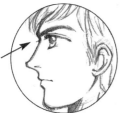

The eyebrow begins close to the glabella.

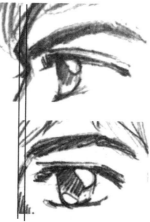

The distance from the face's center line to where the eyebrow starts is short.

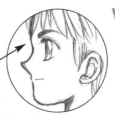

Here, the expanse between the forehead and the glabella is broad.

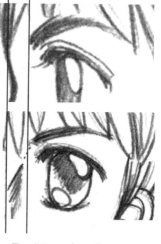

The distance from the face's center line to where the eyebrow starts is long.

Distances between the eye and eyebrow

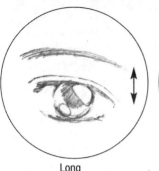

Long

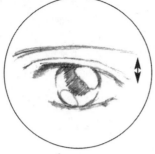

Average

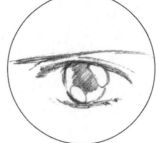

Here, the eye and eyebrow almost touch.

Different combinations of distances between the eye and eyebrow, and then the shape and thickness of the eyebrow yield a limitless number of possible faces.

Four common eyebrows

Thick eyebrows

This almost perfectly straight eyebrow is commonly used on manly characters.

Thin eyebrows

This gracefully arcing eyebrow mimics the line popular amongst women who use eye pencil. Yet, this line is not limited to women and is occasionally used on male characters.

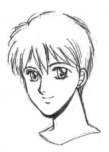

Combination thick/thin eyebrows

This eyebrow tapers near the glabella but thickens as it approaches the corner of the eye.

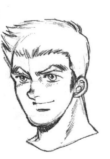

Arched eyebrows

Modifying the thickness, coloring, or shading of this eyebrow changes the mood projected. It is used with male and female characters alike.

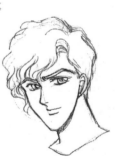

Draw eyebrows on characters with long bangs if the forehead is visible.

Good

Here, a thin eyebrow is drawn between hair strands. While the eyebrow was added in after the hair, it still supplies plenty of expression.

Not good

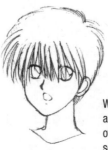

Without any eyebrows, the mouth and eyes do provide a certain degree of expression, but the image still seems lacking.

Drawing Hair

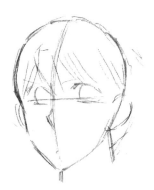
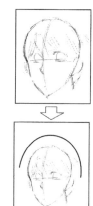

① Draw the face's basic layout. If you draw the face taking up all of the paper, then you may run out of room for the hair, so be sure to anticipate how the hair will lie.

Hair layout allowing for volume

The crown whorl marks the origin of the hair's flow patterns.

To what extent you distance the hair layout from the head's contour (i.e. allow for hair volume) depends on your target hairstyle.

Head contour

② Draw the hair's basic layout

Hair layout allowing for volume

Draw the hairline somewhere between the exterior line of the hair layout and the head contour.

Head contour

③ Build up the target hairstyle while maintaining awareness of the hairline.

The crown whorl actually lies toward the back of the head.

Flow of hair

Lines for the main body of hair and bangs all originate at the crown whorl in the back of the head.

Common Pitfalls: Flat Faces and Scooped-out Heads

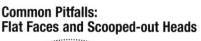
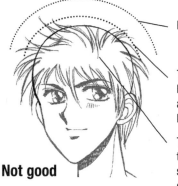

Hair layout

The hairline should have been drawn here and not the hair layout.

The crown whorl was drawn toward the inside, making it seem like the hair was growing from inside the head.

Not good

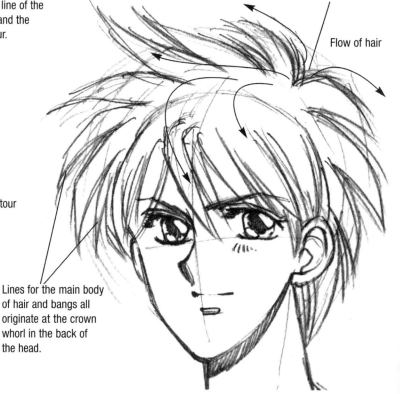

④ Draw in the hair to finish.

How the hair grows:
The crown whorl is located at the back of the head.

The hair originates from the crown whorl. Drawing the hair flowing from somewhere in the back of the head creates the look of 3-dimensional, voluminous hair.

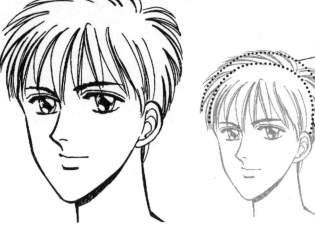

Here, the hair does not have much volume.

The hairline is drawn above the head contour.

Maintaining awareness of the crown whorl when drawing the hairline will enable you to produce a head that is round and has volume-even with short hair.

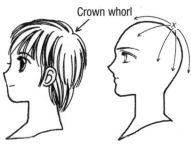

Crown whorl

Draw the hair radiating out from the crown whorl.

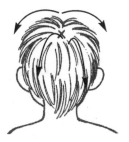

Draw the hair using arced strokes following the head's curved surface.

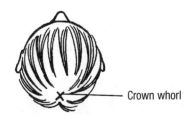

Crown whorl

Positioning the crown whorl at the back of the head means that long, curved strokes must be used for the hair in the front, allowing you to suggest the head's curved surface.

Keeping the Crown Whorl to the Back

Positioning the crown whorl toward the front will cause your character to have dweeby hair. Despite that the crown whorl will not be visible from the front, still draw the hair as if growing from somewhere in the back.

Moving the crown whorl to the front may cause the head to lose its sense of volume.

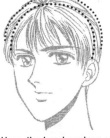

Here, the head contour and hair layout have been handled the same as in the figures above.

Positioning the crown whorl at the very top or toward the front of the head will cause the curved strokes used for the front hair to shorten, while those for the back to become longer, flattening the head.

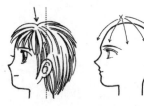

Good

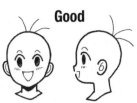

Positioning the crown whorl at the back of the head will, at the very least, give the hair visually consistent roots.

Not good

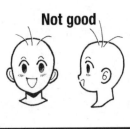

Positioning the crown whorl at the very top or toward the front of the head will make the roots (i.e. how the hair grows) appear awkward.

Maintaining Awareness of the Direction of the Crown Whorl

The crown whorl may swirl to the right or left. Think about how to direct the swirl when drawing the crown whorl in the back of the head and when designing the hairstyle.

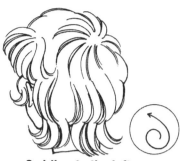

Swirling to the left

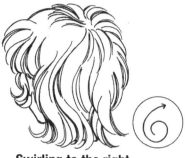

Swirling to the right

Here, the whorl's center flows to the right. The hair flows in the opposite direction on the left side.

Crown whorl

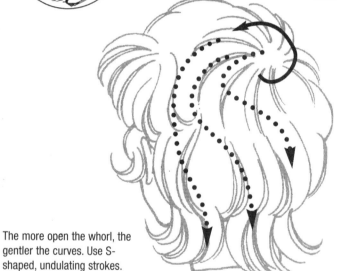

The more open the whorl, the gentler the curves. Use S-shaped, undulating strokes.

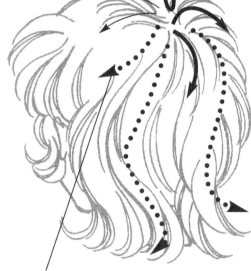

This whorl, located at the back of the head, flows to the right.

Swirling hair

From the front view, the hair swirls to the right.

From the back view, the hair swirls to the left.

Swirling hair with realism

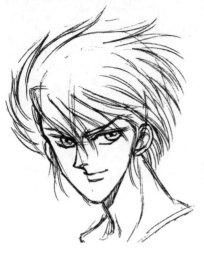

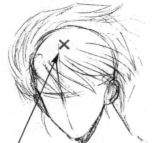

When sketching the hair layout, assume that the crown whorl will be positioned in the back.

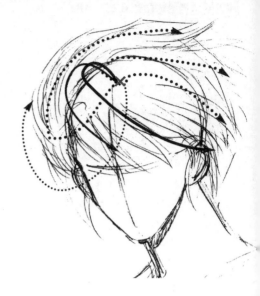

Single-length hair

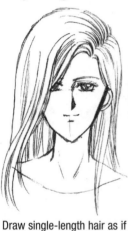

These strands fall toward the viewer.

Draw single-length hair as if flowing in 3 directions.

Hair to the back and opposite side flow in the reverse direction.

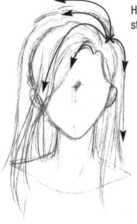

Here, the hair falls straight downward.

When drawing long, single-length hair, select a part and draw the hair flowing in large waves from that point.

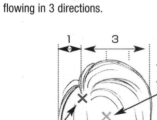

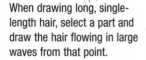

The true position of the crown whorl

Where the hair is parted

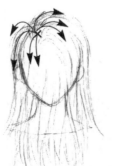

When drawing the back of the head, first draw the head's contour and the ears, using these as guidelines for determining the hair's volume and flow.

Drawing the hair falling in a gentle S-curve from where it touches the shoulder gives it a supple look.

Hair grows like grass.

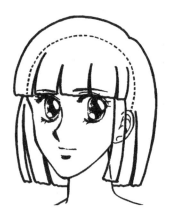

A head will increase in size according to the volume of the hair drawn. This is because hair actually grows from the scalp outward, covering the head's contours.

Grass always grows upward and then falls over from its own weight.

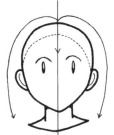

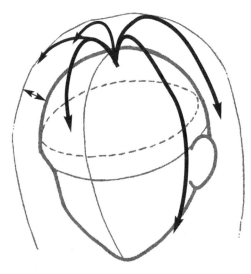

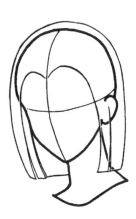

Hair grows in a radiating pattern from the root. Think of the crown whorl as basically the hair's root and individual strands as grass blades.

The amount of volume created by the hair depends on its stiffness and weight. The more strands and stiffer the hair, the more voluminous it becomes. The fewer the strands and softer the hair, the more the hair appears plastered to the head.

Think of hair as enveloping the head's contours, forming a "layer of hair."

Good

When consideration is not given to the hair's volume

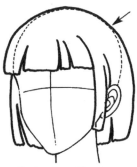

Here, the hair layout has been drawn against the head's contour.

Not good

The resulting head appears flat and distorted. Not a pleasing sight.

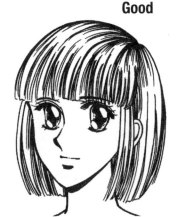

Here, the hair was drawn with the part to the top left (character's perspective). While the identical face was used on both figures, this head has been given extra volume.

Hair with 2 parts:
Primarily for hairstyles with bangs

Creating 2 Parts

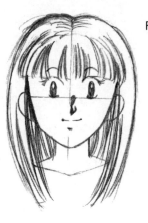

Front part for bangs

Back part for hair flowing to the sides and along the head's contours

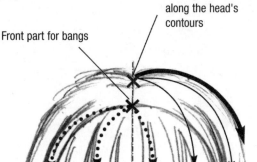

Front part Back part

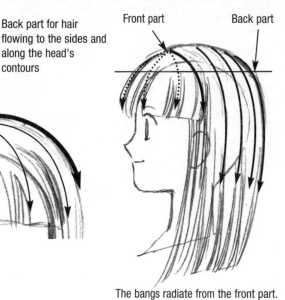

The bangs radiate from the front part. The sides fall in gentle, almost parallel curves. The back part is located at the crest of the head.

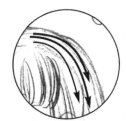

Drawing hair falling along the sketched hair layout gives the hair volume.

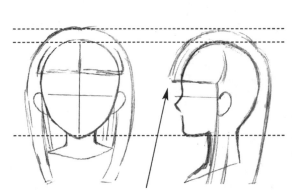

Give the hair overall volume matching it to that of the bangs.

Drawing hair from the back

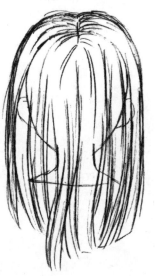

Back part

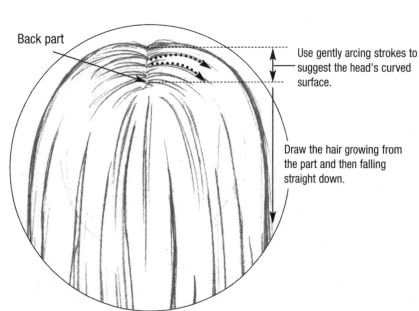

Use gently arcing strokes to suggest the head's curved surface.

Draw the hair growing from the part and then falling straight down.

Profiles and Hair Movement

Shoulder-length with bangs

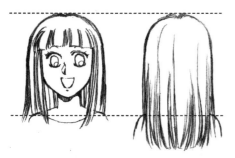

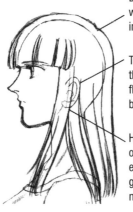

Draw the crown whorl as a slight indent.

The ear's helix forms the beginning of the flow of the hair in the back.

Having the front tress of hair divide at the ear's center. This will give the flow a natural feel.

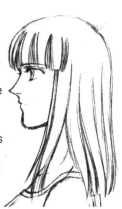

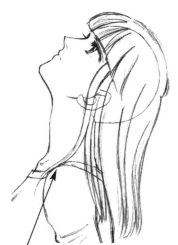

The lock in front of the ear forms an S-curve when looking up.

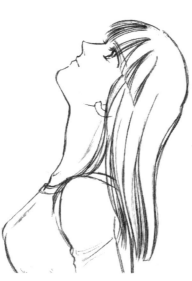

Note that normally when the head is tilted up, this lock will not lift like this.

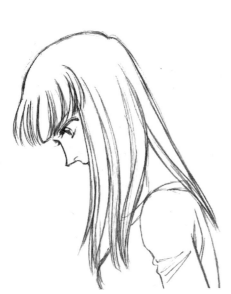

To start, draw just the general shape of the hair and fill in the details last. Increase the level of detail, using more strokes as you approach the ends of the hair.

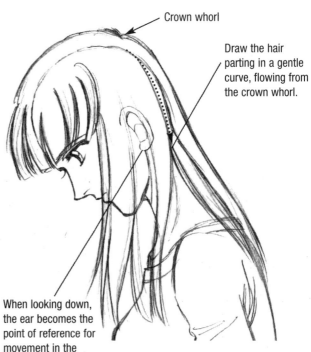

Crown whorl

Draw the hair parting in a gentle curve, flowing from the crown whorl.

When looking down, the ear becomes the point of reference for movement in the hair.

66

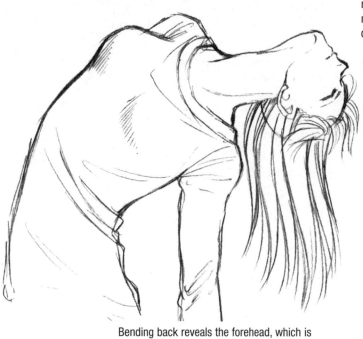

Bending back causes the hair to flip back, potentially making the character look like another person. In manga, albeit unrealistic, the bangs are occasionally drawn lying on the forehead to rectify this.

Bending back reveals the forehead, which is usually concealed by the bangs with this hairstyle.

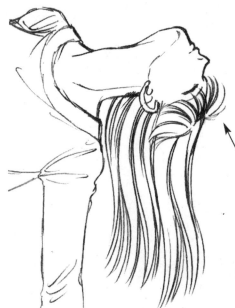

Here, the original hairstyle was emphasized. The ends of the hair fan out, offering variation on the look. The forehead is concealed.

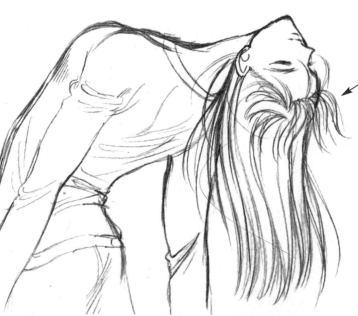

Merely concealing or exposing the forehead results in an entirely different look.

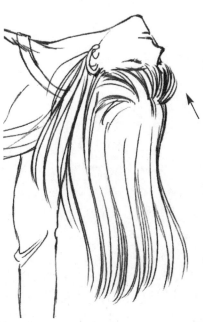

Short hair without bangs

Draw the hair roundish overall and tucking under the chin.

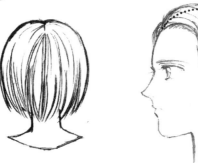

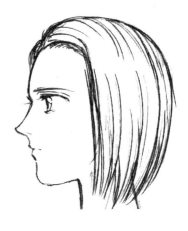

In the profile, the hair should have little volume and hug closely to the head's contours.

Tilting the head back makes the hairline prominent.

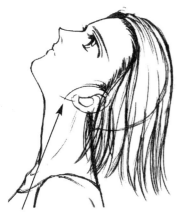

Tiling the head back exposes the ear. This strand is defying gravity.

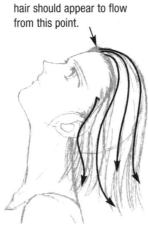

With the hair flipped back, the hair should appear to flow from this point.

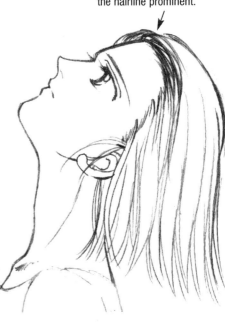

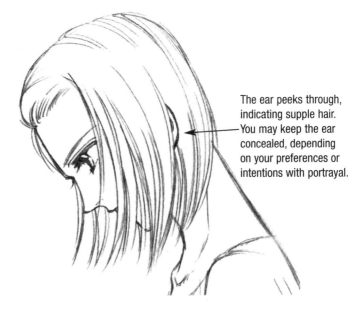

The ear peeks through, indicating supple hair. You may keep the ear concealed, depending on your preferences or intentions with portrayal.

Looking down causes the hair to divide at the ear's helix.

Unlike with the head tilted back, here the ends of the hair all face the same direction.

Big, curly hair

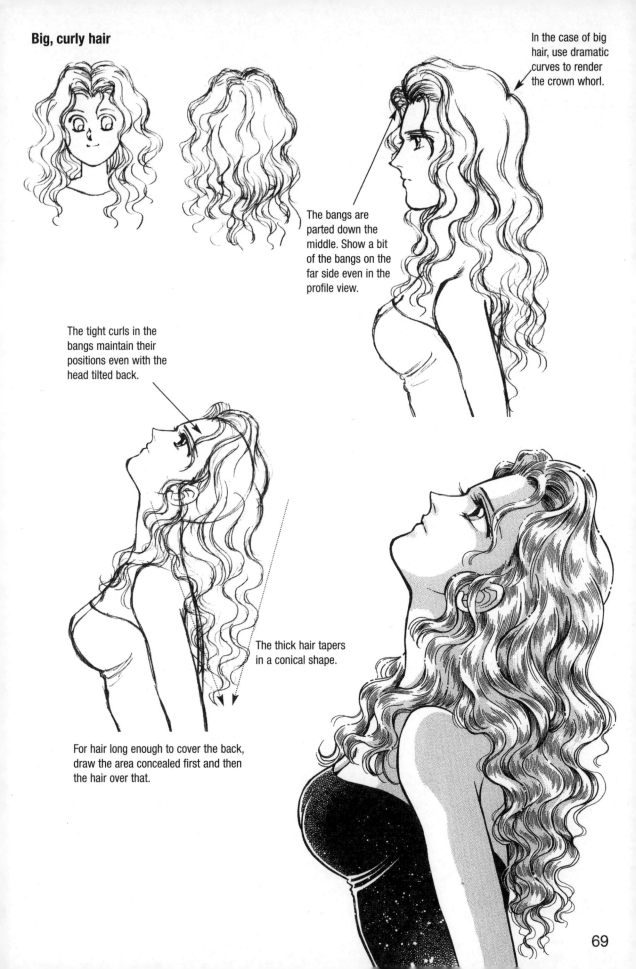

In the case of big hair, use dramatic curves to render the crown whorl.

The bangs are parted down the middle. Show a bit of the bangs on the far side even in the profile view.

The tight curls in the bangs maintain their positions even with the head tilted back.

The thick hair tapers in a conical shape.

For hair long enough to cover the back, draw the area concealed first and then the hair over that.

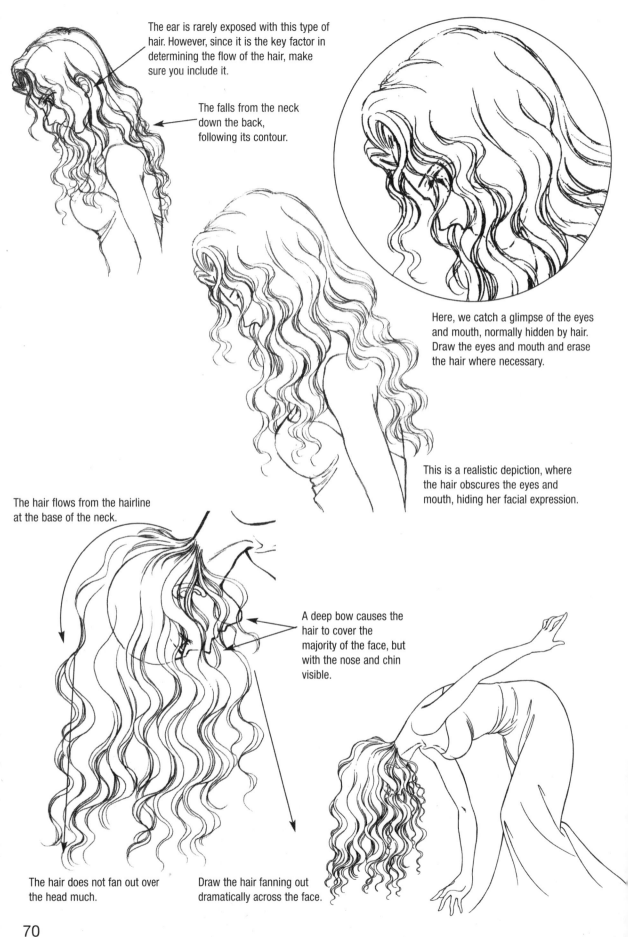

The ear is rarely exposed with this type of hair. However, since it is the key factor in determining the flow of the hair, make sure you include it.

The falls from the neck down the back, following its contour.

Here, we catch a glimpse of the eyes and mouth, normally hidden by hair. Draw the eyes and mouth and erase the hair where necessary.

This is a realistic depiction, where the hair obscures the eyes and mouth, hiding her facial expression.

The hair flows from the hairline at the base of the neck.

A deep bow causes the hair to cover the majority of the face, but with the nose and chin visible.

The hair does not fan out over the head much.

Draw the hair fanning out dramatically across the face.

Kinky bob cut

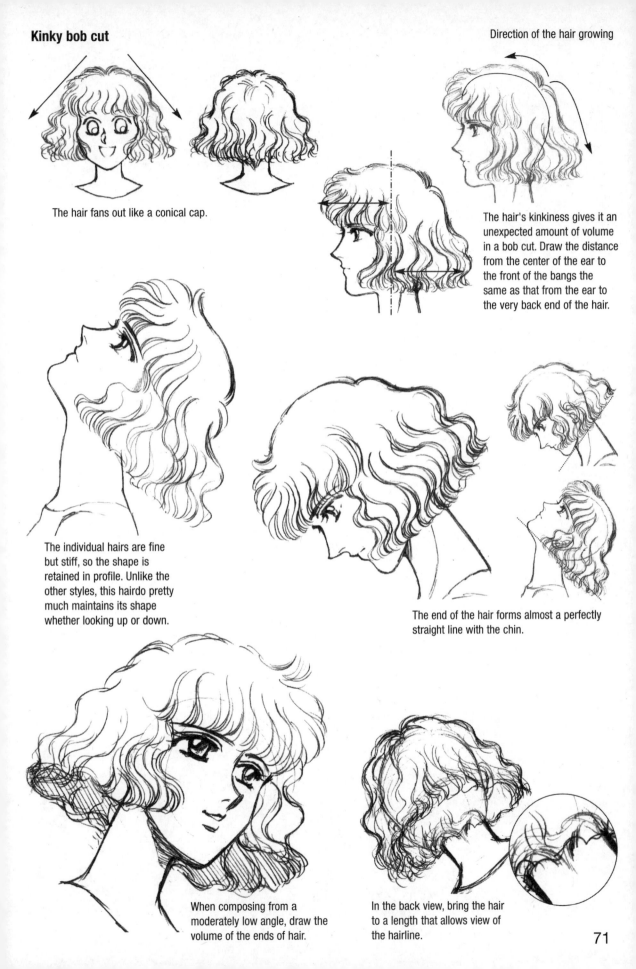

The hair fans out like a conical cap.

The hair's kinkiness gives it an unexpected amount of volume in a bob cut. Draw the distance from the center of the ear to the front of the bangs the same as that from the ear to the very back end of the hair.

The individual hairs are fine but stiff, so the shape is retained in profile. Unlike the other styles, this hairdo pretty much maintains its shape whether looking up or down.

The end of the hair forms almost a perfectly straight line with the chin.

When composing from a moderately low angle, draw the volume of the ends of hair.

In the back view, bring the hair to a length that allows view of the hairline.

The pompadour

The front pouf is combed back.

The temple is shaved into a wedge-shape.

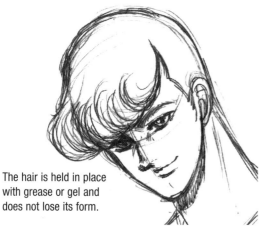

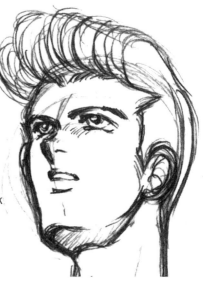

The hair is held in place with grease or gel and does not lose its form.

The hairline is exposed, owing to the flipped back front.

Slicked back hair

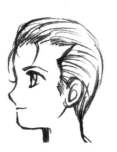
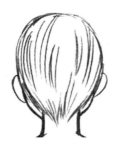

Since the hair is slicked entirely back, there is no need to draw the crown whorl.

Since the emphasis lies on keeping the hair slick against the skull, the artist must make sure the head is drawn properly.

When switching the direction faced, maintain awareness of the hairline and take care that the forehead's expanse does not change.

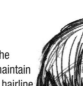
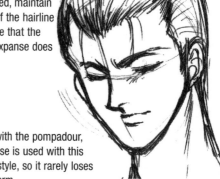

The bangs tend to fall as time passes and may be suggesting by drawing several strands falling down in front.

As with the pompadour, grease is used with this hairstyle, so it rarely loses its form.

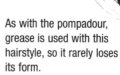

Chapter 3
Drawing the Figure

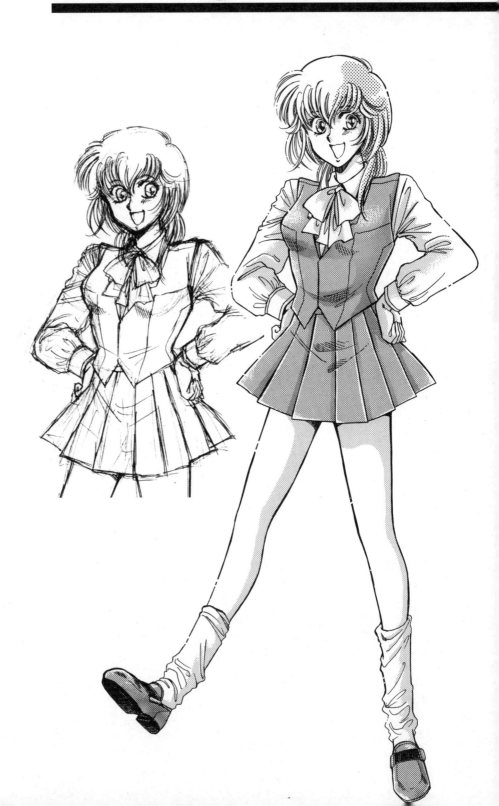

Key Points in Drawing the Figure

Legs occupy half the total height.

Making the legs half the total height will give the character an attractive appearance.

Upper body

Halfway mark

Legs

For the figure's basic layout, start with a sewing pin.

① Draw a straight line ending in a circle.

② Draw a line at the top of the head and at the feet to determine the height.

③ Draw the halfway mark. This will determine the figure's upper and lower halves.

Tricks to plotting the head's layout when drawing the figure

Draw the head's layout at a size that includes the hair. Note that its size should not reflect solely the face.

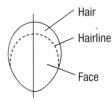

Hair

Hairline

Face

Draw a line indicating the hairline.

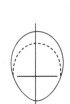

Draw an X through the face.

Posing figure layouts

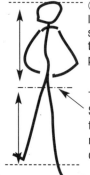

① Here we see a skeletal layout. Start with a basic stick figure like this, trying to capture your target pose.

This is the halfway mark. Shifting this just above the groin will result in a moderately leggy character.

② Draw the joints: use circles for the shoulders, the elbows, and knees.

There are rules for plotting the elbows and knees: the elbows lie halfway along the arms, while the knees lie halfway along the legs.

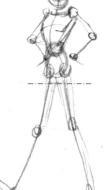

③ Use blocks to flesh out the stick figure, plotting the full figure layout.

The Basic Proportions

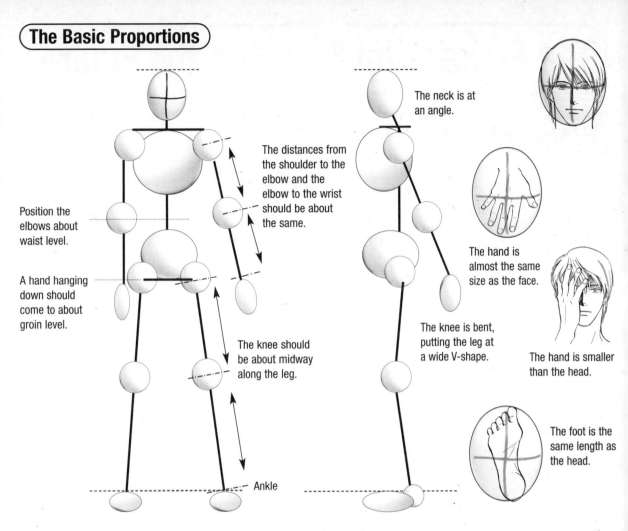

Position the elbows about waist level.

A hand hanging down should come to about groin level.

The distances from the shoulder to the elbow and the elbow to the wrist should be about the same.

The knee should be about midway along the leg.

Ankle

The neck is at an angle.

The knee is bent, putting the leg at a wide V-shape.

The hand is almost the same size as the face.

The hand is smaller than the head.

The foot is the same length as the head.

The elbows and knees are plotted the same, regardless of the rendering style or character

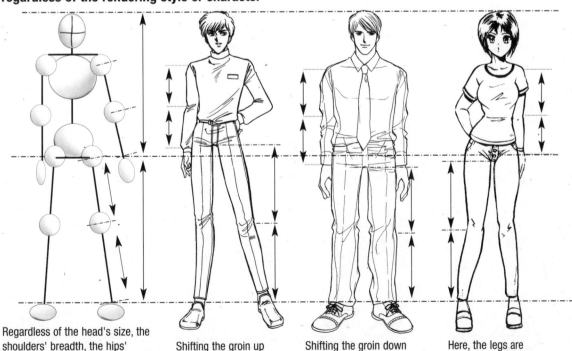

Regardless of the head's size, the shoulders' breadth, the hips' position, the feet's size, etc., the elbows and knees are still plotted in the same positions.

Shifting the groin up results in a somewhat long-legged character.

Shifting the groin down results in a short-legged character.

Here, the legs are located about midway along the body.

The Process for Drawing the Figure

Drawing from a Frontal, Standing Position

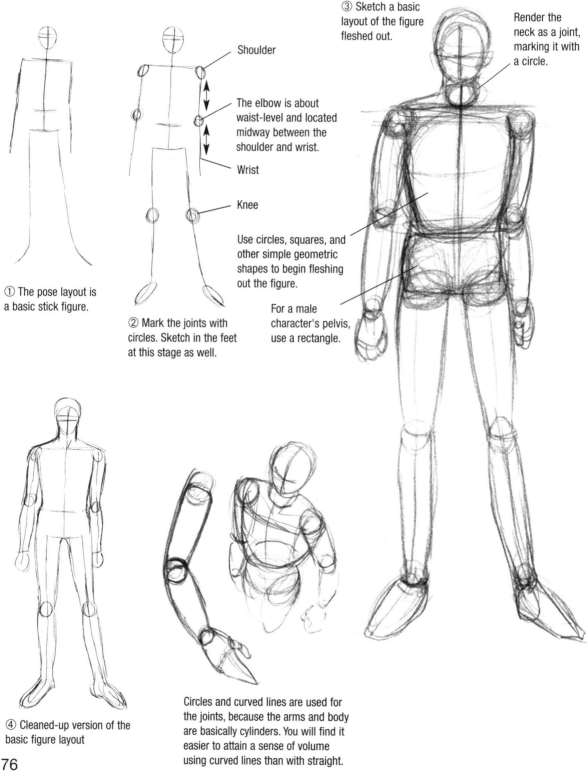

③ Sketch a basic layout of the figure fleshed out.

Render the neck as a joint, marking it with a circle.

Shoulder

The elbow is about waist-level and located midway between the shoulder and wrist.

Wrist

Knee

Use circles, squares, and other simple geometric shapes to begin fleshing out the figure.

For a male character's pelvis, use a rectangle.

① The pose layout is a basic stick figure.

② Mark the joints with circles. Sketch in the feet at this stage as well.

④ Cleaned-up version of the basic figure layout

Circles and curved lines are used for the joints, because the arms and body are basically cylinders. You will find it easier to attain a sense of volume using curved lines than with straight.

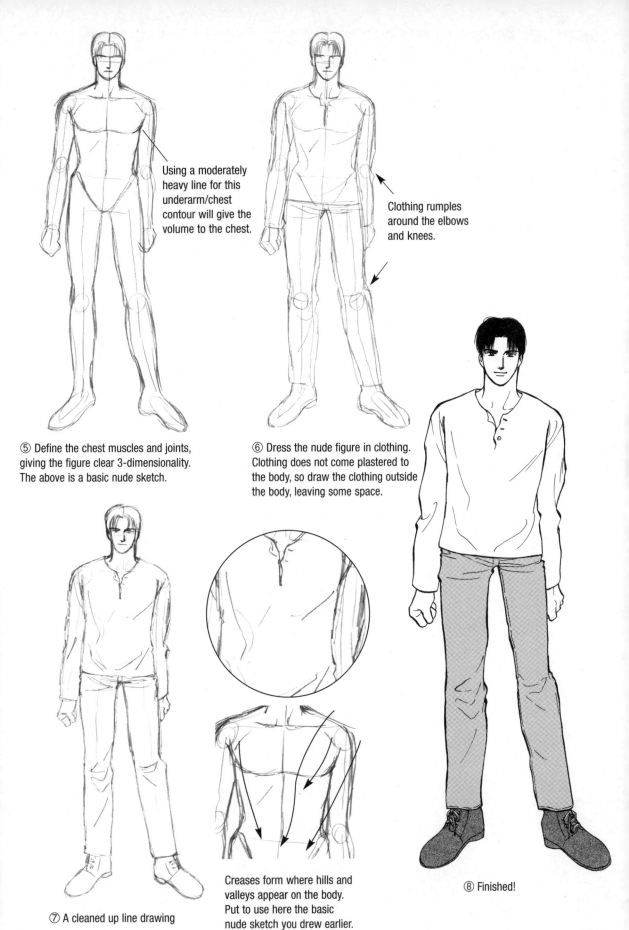

Using a moderately heavy line for this underarm/chest contour will give the volume to the chest.

Clothing rumples around the elbows and knees.

⑤ Define the chest muscles and joints, giving the figure clear 3-dimensionality. The above is a basic nude sketch.

⑥ Dress the nude figure in clothing. Clothing does not come plastered to the body, so draw the clothing outside the body, leaving some space.

⑦ A cleaned up line drawing

Creases form where hills and valleys appear on the body. Put to use here the basic nude sketch you drew earlier.

⑧ Finished!

The Female Form

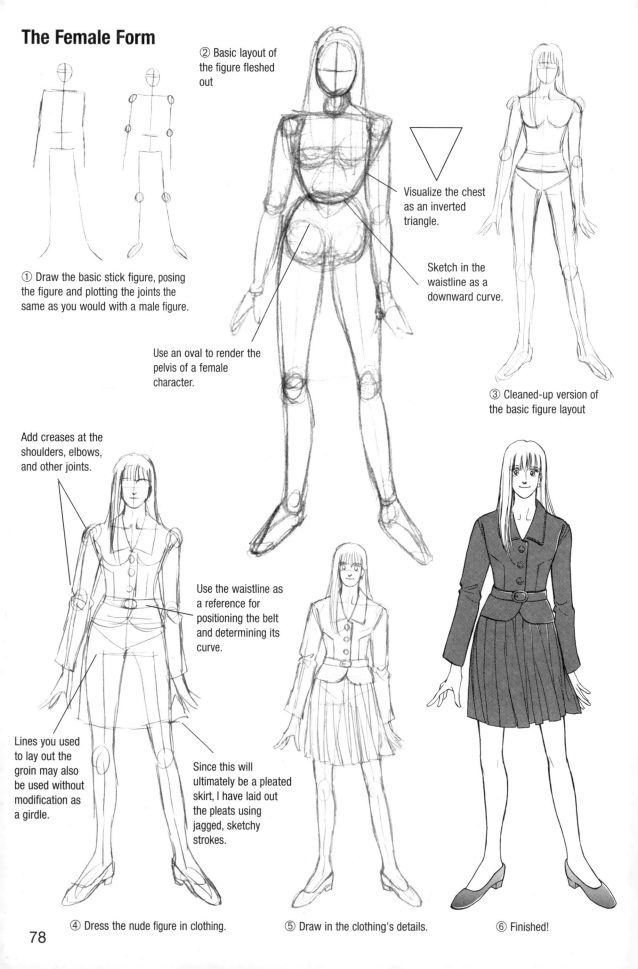

① Draw the basic stick figure, posing the figure and plotting the joints the same as you would with a male figure.

② Basic layout of the figure fleshed out

Use an oval to render the pelvis of a female character.

Visualize the chest as an inverted triangle.

Sketch in the waistline as a downward curve.

③ Cleaned-up version of the basic figure layout

Add creases at the shoulders, elbows, and other joints.

Use the waistline as a reference for positioning the belt and determining its curve.

Lines you used to lay out the groin may also be used without modification as a girdle.

Since this will ultimately be a pleated skirt, I have laid out the pleats using jagged, sketchy strokes.

④ Dress the nude figure in clothing.

⑤ Draw in the clothing's details.

⑥ Finished!

Drawing Side Views

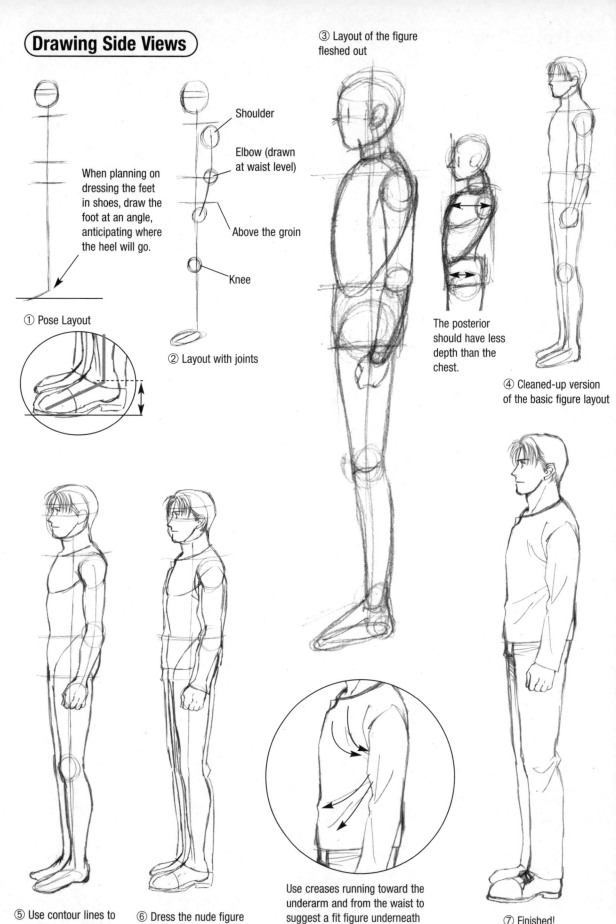

When planning on dressing the feet in shoes, draw the foot at an angle, anticipating where the heel will go.

① Pose Layout

Shoulder

Elbow (drawn at waist level)

Above the groin

Knee

② Layout with joints

③ Layout of the figure fleshed out

The posterior should have less depth than the chest.

④ Cleaned-up version of the basic figure layout

⑤ Use contour lines to give the figure volume.

⑥ Dress the nude figure in clothing.

Use creases running toward the underarm and from the waist to suggest a fit figure underneath the clothing.

⑦ Finished!

The Female Form

① The basic stick figure is drawn the same as with a male figure.

② Basic layout of the figure fleshed out

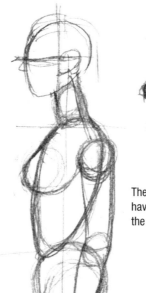

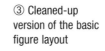

The posterior should have more depth than the chest.

③ Cleaned-up version of the basic figure layout

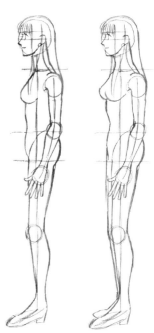

Side view Skewed side view

Side view

Skewed side view

④ Dress the nude figure in clothing. The skewed side view has a slightly more "fashion magazine" type feel and is more flattering to the chest.

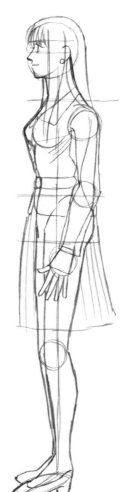

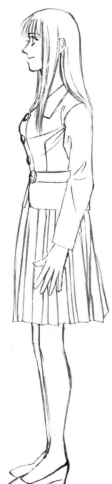

⑤ Draw in the clothing's details. ⑥ Finished!

Back View

① Posed stick figure and layout with joints

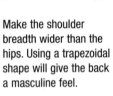

② Layout of the figure fleshed out

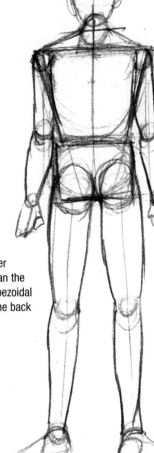

Make the shoulder breadth wider than the hips. Using a trapezoidal shape will give the back a masculine feel.

③ Cleaned-up version of the basic figure layout

The shoulder blades become a key point in drawing clothing creases.

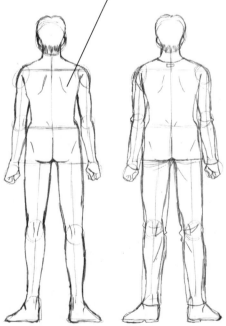

④ Use contour lines to give the figure volume.

⑤ Add clothing.

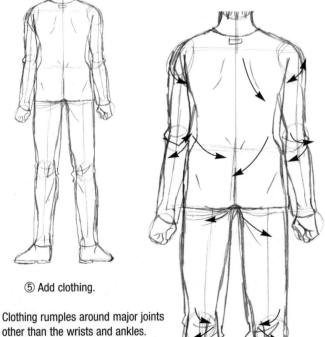

Clothing rumples around major joints other than the wrists and ankles. Imagining the creases forming in a "coiling" pattern when drawing them will give the muscles volume.

⑥ Finished!

The Female Form

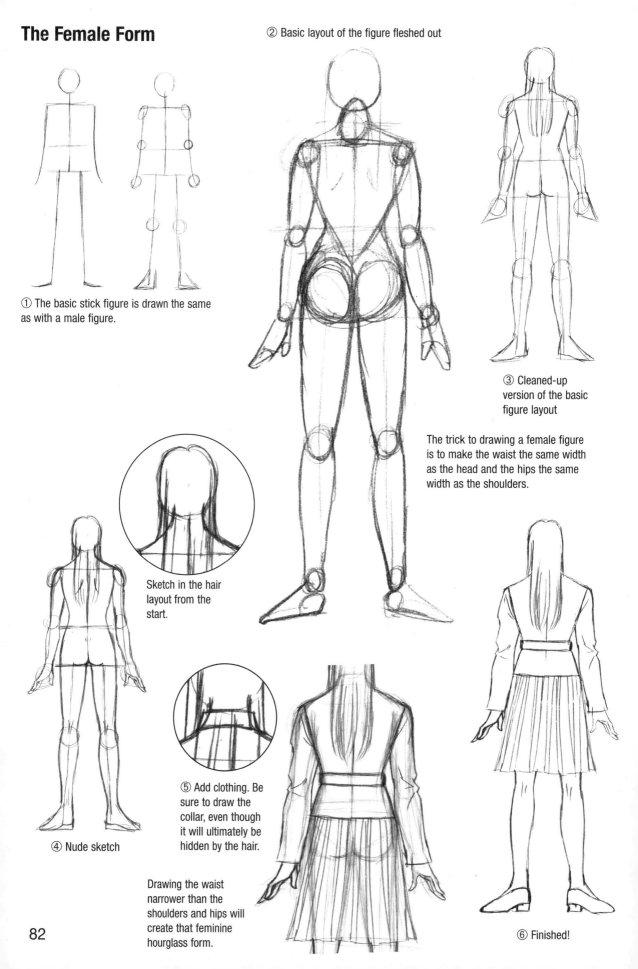

② Basic layout of the figure fleshed out

① The basic stick figure is drawn the same as with a male figure.

③ Cleaned-up version of the basic figure layout

The trick to drawing a female figure is to make the waist the same width as the head and the hips the same width as the shoulders.

Sketch in the hair layout from the start.

④ Nude sketch

⑤ Add clothing. Be sure to draw the collar, even though it will ultimately be hidden by the hair.

Drawing the waist narrower than the shoulders and hips will create that feminine hourglass form.

⑥ Finished!

Assorted Pose Layouts

You can draw any pose by
starting with a layout.

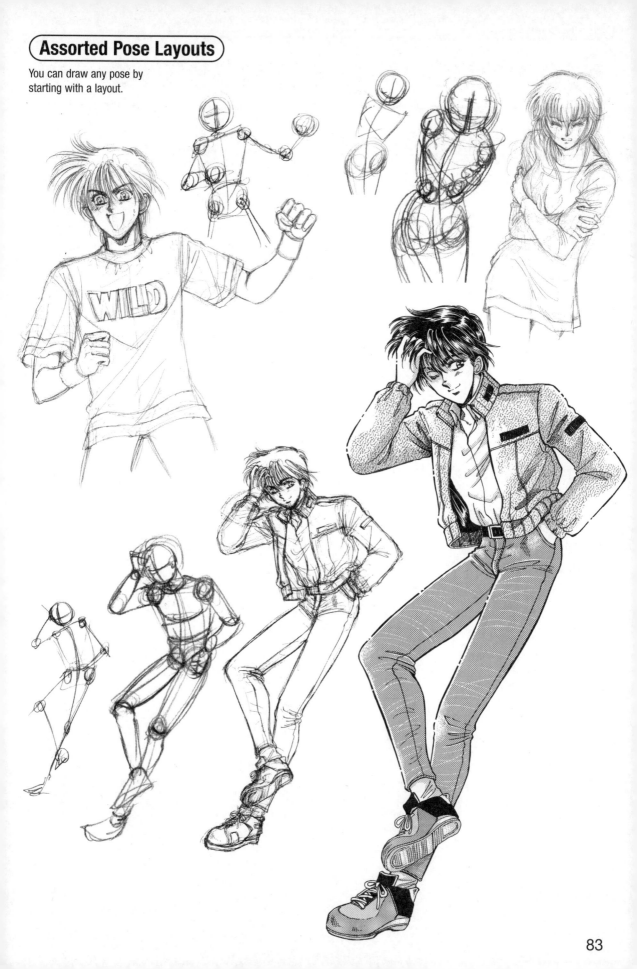

Proportioning Characters

The Body-to-Head Ratio Is the Key

The balance between the arms and legs and the torso constitutes the key to designing a good-looking character. To achieve this, artists use the head as a reference measurement for the figure overall. The body-to-head ratio refers to how many head lengths measure the figure's total height. A character that is 6 heads tall has a 6:1 body-to-head ratio. One that is 8 heads tall has an 8:1 ratio, and so on.

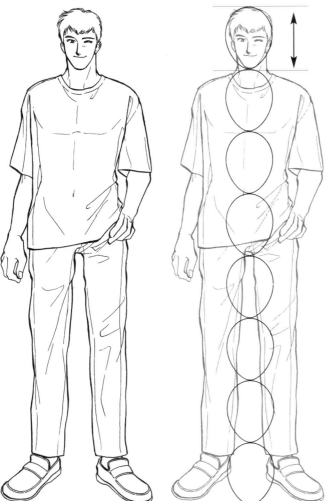

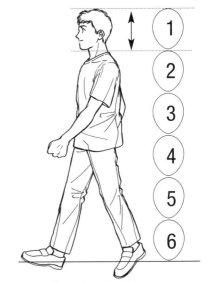

Character with a 6:1 body-to-head ratio

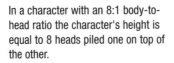

In a character with an 8:1 body-to-head ratio the character's height is equal to 8 heads piled one on top of the other.

Here is a contrast between an 8:1 character and a 6:1 character. The differences in head sizes causes 2 characters of identical height to have different body-to-head ratios, affecting the characters' appearances and atmospheres projected.

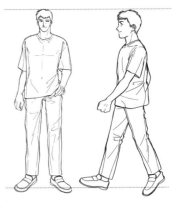

Use a ruler to plot the body-to-head ratio.

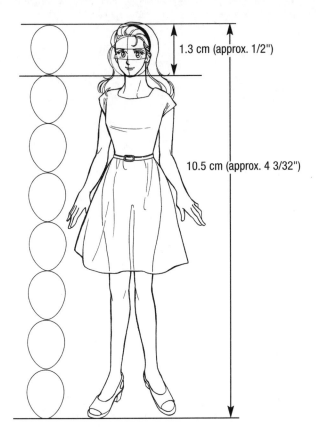

1.3 cm (approx. 1/2")

10.5 cm (approx. 4 3/32")

The body-to-head ratio is the total height divided by the head length. The body-to-head ratio of the character to the left is—

10.5 cm ÷ 1.3 cm = 8

Thus, this character has a body-to-head ratio of 8:1.

8:1 ratio vs. 6:1 ratio

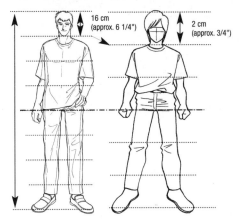

16 cm (approx. 6 1/4")

2 cm (approx. 3/4")

Measure the character's height and divide it by the number of heads (for the target body-to-head ratio) to determine the head's length.
Eg. For a character 16 cm tall:

- At an 8:1 ratio
 The head is 16 ÷ 8 or 2 cm

- At a 6:1 ratio
 The head is 16 ÷ 6 or approx. 2.7 cm

What happens if the character's body-to-head ratio suddenly changes within a work?

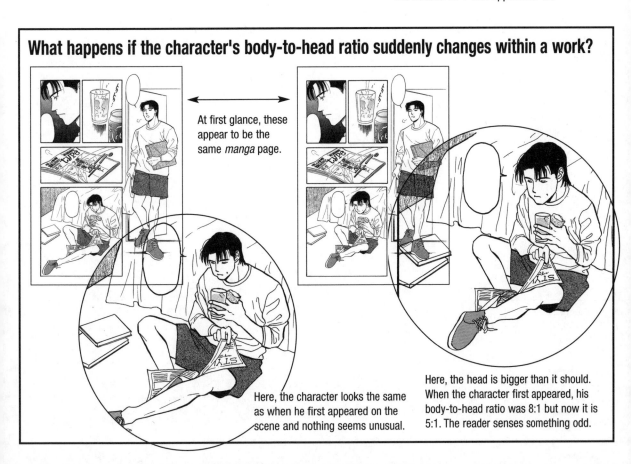

At first glance, these appear to be the same *manga* page.

Here, the character looks the same as when he first appeared on the scene and nothing seems unusual.

Here, the head is bigger than it should. When the character first appeared, his body-to-head ratio was 8:1 but now it is 5:1. The reader senses something odd.

Balancing Proportions

All three figures are the same height and their heads are the same length, giving them a body-to-head ratio of 6:1.

The figure's proportions are balanced by adjusting the positions of the waist and groin. Characters with the same body-to-head ratio can be distinguished by the positions of their waists and groins.

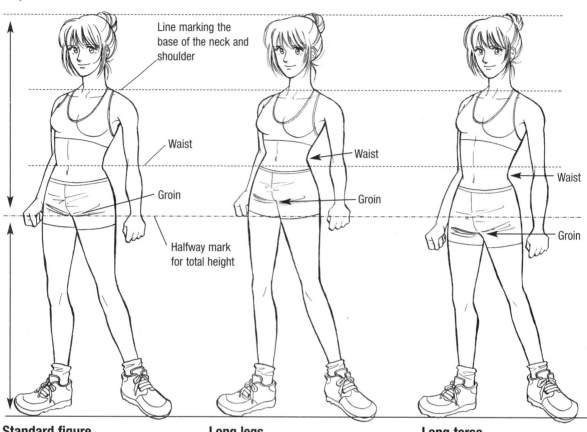

Line marking the base of the neck and shoulder

Waist

Groin

Halfway mark for total height

Waist

Groin

Waist

Groin

Standard figure
(The legs constitute 1/2 of the total height)

Long legs
(The groin and waist are located high on the figure.)

Long torso
(The groin and waist are located low on the figure.)

Sample proportion balancing by to body-to-head ratio

It is not necessarily true that all characters must be drawn with the groin positioned halfway along the figure. Characters with body-to-head ratios of 5:1 look awkward with their legs taking up half their bodies.

Halfway mark for total height

Groin

Groin

A 5:1 ratio is ideal for boys and girls in the 9 to 12-year range. The groin is positioned just low of the halfway mark, making the legs slightly on the short side.

A 4.5:1 ratio works well for 5 to 8 year olds.

A 4:1 ratio means a large head. This is suited to preschoolers around 3 to 5. The legs are short

Differences in Height vs. Differences in Body-to-Head Ratios

Note that changing a character's height means that you will also have to change that character's body-to-head ratio.

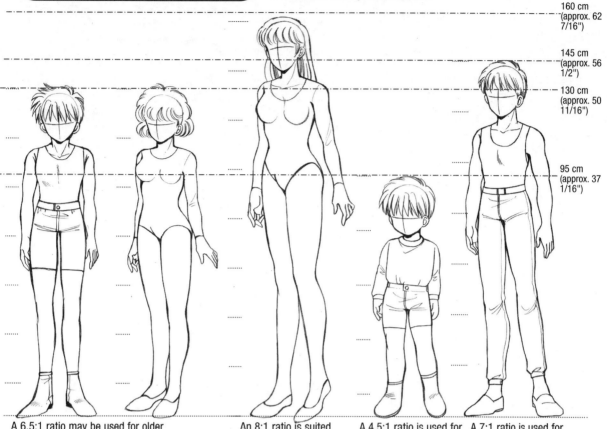

160 cm (approx. 62 7/16")

145 cm (approx. 56 1/2")

130 cm (approx. 50 11/16")

95 cm (approx. 37 1/16")

A 6.5:1 ratio may be used for older elementary school students. This can be used for boys and girls alike who are aged about 9 to 12 years. This ratio may also be used with middle school girls about 13 to 15 years.

An 8:1 ratio is suited toward high school student and adult male and female characters.

A 4.5:1 ratio is used for young elementary school students around 5 to 6 years.

A 7:1 ratio is used for middle to high school students, both boys and girls alike, between 13 and 17 years.

Characters with different heights but identical body-to-head ratios

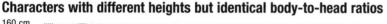

160 cm (approx. 62 7/16")

140 cm (approx. 54 5/8")

120 cm (approx. 46 13/16")

80 cm (approx. 31 1/4")

All three figures have a 7:1 ratio

6:1 ratio

Putting a 7:1 character and a 6:1 character of different heights side by side gives the appearance of only a difference in height existing.

Setting the height to 180 cm, the same proportions may be used for high-school aged characters and older.

At this height, the figure looks like a leggy boy.

Now the figure just appears to be the 160-cm character seen from a distance.

This figure appears to be an elementary school to middle school aged boy.

When we stand a 7:1 character and a 6:1 character of the same height side by side, the two characters immediately appear different. (This is also because normally, these characters would be drawn with different faces and hairstyles as well.)

Keeping Male and Female Characters Distinct

Male character

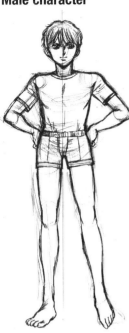

A 7:1 ratio is suited to adolescent boys to adult male characters.

The groin is usually located halfway along the figure; however, when you intend to make the character a little leggy (like this one), move it north of the halfway mark.

Halfway mark

The chest is usually located about 1-head length below the head.

Position the waist between the chest and the groin. The pelvis (hips) should be drawn wider when the waist is positioned higher and narrower when the waist is positioned lower.

Since the groin has been raised, the knees likewise have been raised by the same amount. Long calves present a slender image.

Halfway mark for the legs

Female character

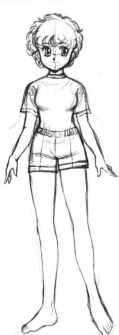

A 6:1 ratio is suited toward cutesy characters from about elementary school to high school in age.

The breasts start to swell about here. While they are positioned a bit higher than they would in reality, this offers a cute, *manga*-ish look.

For this figure, I moved the groin above the halfway mark, making her a little leggy.

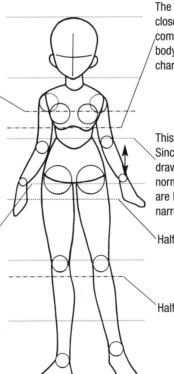

The chest is situated close to the waist, compressing the upper body, giving the character a "cute" look.

This marks the waist. Since the groin has been drawn higher than its normal position, the hips are likewise made narrower.

Halfway mark

Halfway mark for the legs

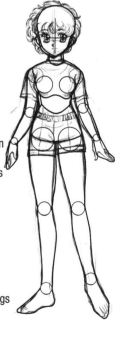

88

Key points in distinguishing male and female characters

Adjust the height

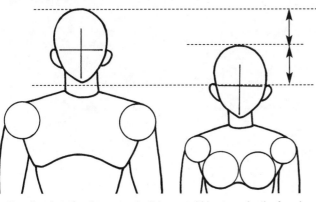

Usually when drawing a couple, it is a good idea to make the female character shorter than the male. Use about a half or full head shorter in height as your rule of thumb.

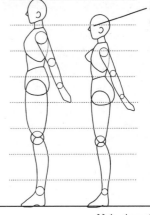

The woman's eye comes to about the man's chin.

Male character: 8:1
Female character: 7.5:1

Adjust the proportional balance

Give your male characters broad shoulders about twice the head's length to get a properly masculine look.

Give your female characters narrow shoulders about 1.5 times the head's length.

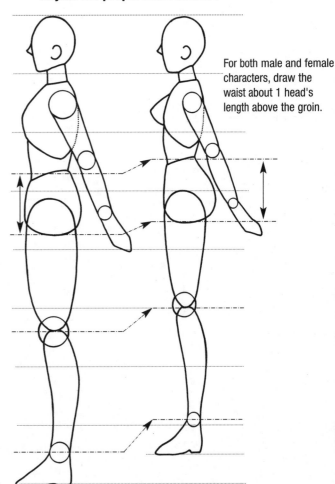

For both male and female characters, draw the waist about 1 head's length above the groin.

Adjust depths

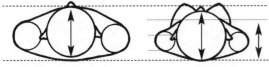

The heads are equal in depth for both male and female characters. However, the male character has a thicker chest about the same depth as his head.

Female characters have shallower chests. Aim for about 3/4 that of the male character (excluding the breasts).

Differences in layouts for male and female characters

Adjust the size of the circles used for the joints.

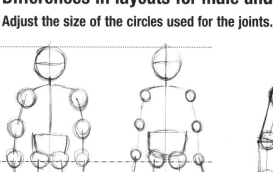

Male character Female character

Give male characters larger joints and female characters smaller ones. At this stage, the shoulders and pelvis may be drawn the same size for both sexes.

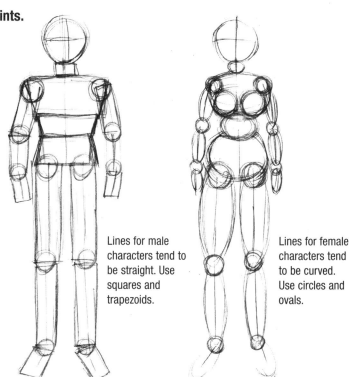

Lines for male characters tend to be straight. Use squares and trapezoids.

Lines for female characters tend to be curved. Use circles and ovals.

The male torso is an inverted triangle.

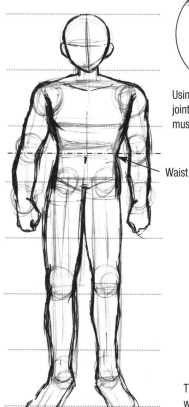

Using large circles for the joints will facilitate drawing muscular, masculine arms.

Waist

The torso tapers toward the waist, and the hips are narrower than the shoulders.

The female torso is a triangle.

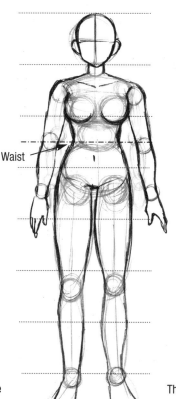

Using small circles for the joints will help you produce slender, feminine arms.

Waist

The torso broadens expansively from the waist, and the hips are wide.

Using the Body-to-Head Ratio to Draw Characters without Bounds

Measure body-to-head ratios.

Just what do you think the body-to-head ratios for the figures on this page are? When you find a character in a work of *manga* that appeals to you and think you would like to draw it, take a careful look not only at the character's face or clothing, but also the body and head's proportions. These are the key ingredients to drawing a visually pleasing character.

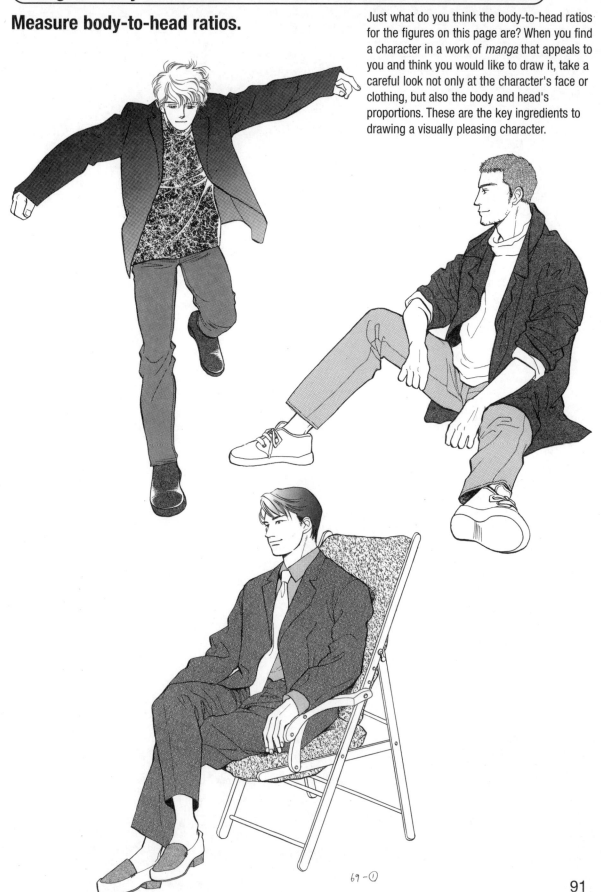

69 – ①

Measuring body-to-head ratios

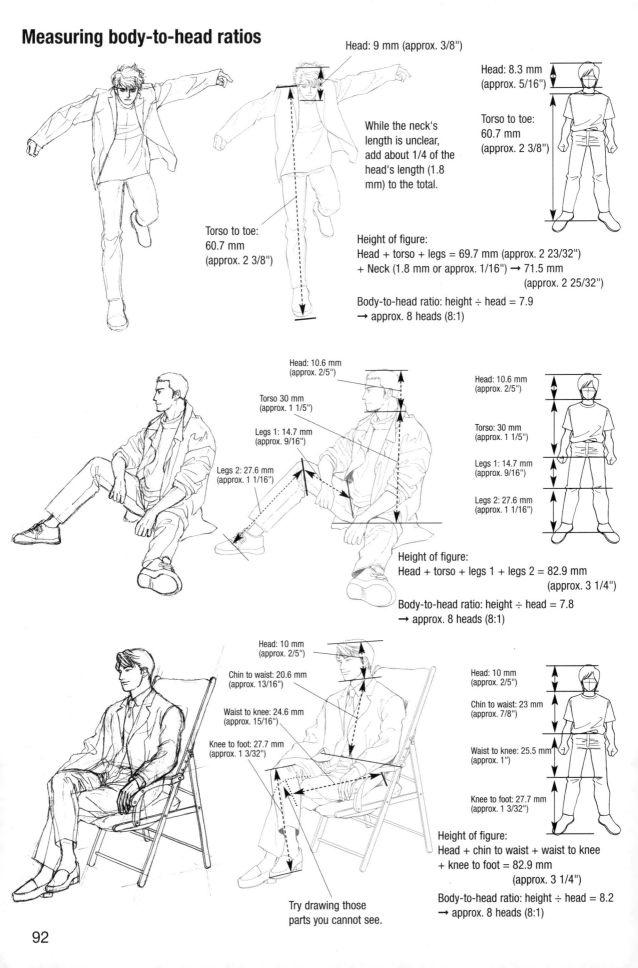

Head: 9 mm (approx. 3/8")

While the neck's length is unclear, add about 1/4 of the head's length (1.8 mm) to the total.

Torso to toe: 60.7 mm (approx. 2 3/8")

Head: 8.3 mm (approx. 5/16")

Torso to toe: 60.7 mm (approx. 2 3/8")

Height of figure:
Head + torso + legs = 69.7 mm (approx. 2 23/32")
+ Neck (1.8 mm or approx. 1/16") → 71.5 mm
(approx. 2 25/32")

Body-to-head ratio: height ÷ head = 7.9
→ approx. 8 heads (8:1)

Head: 10.6 mm (approx. 2/5")

Torso 30 mm (approx. 1 1/5")

Legs 1: 14.7 mm (approx. 9/16")

Legs 2: 27.6 mm (approx. 1 1/16")

Head: 10.6 mm (approx. 2/5")

Torso: 30 mm (approx. 1 1/5")

Legs 1: 14.7 mm (approx. 9/16")

Legs 2: 27.6 mm (approx. 1 1/16")

Height of figure:
Head + torso + legs 1 + legs 2 = 82.9 mm
(approx. 3 1/4")

Body-to-head ratio: height ÷ head = 7.8
→ approx. 8 heads (8:1)

Head: 10 mm (approx. 2/5")

Chin to waist: 20.6 mm (approx. 13/16")

Waist to knee: 24.6 mm (approx. 15/16")

Knee to foot: 27.7 mm (approx. 1 3/32")

Head: 10 mm (approx. 2/5")

Chin to waist: 23 mm (approx. 7/8")

Waist to knee: 25.5 mm (approx. 1")

Knee to foot: 27.7 mm (approx. 1 3/32")

Try drawing those parts you cannot see.

Height of figure:
Head + chin to waist + waist to knee
+ knee to foot = 82.9 mm
(approx. 3 1/4")

Body-to-head ratio: height ÷ head = 8.2
→ approx. 8 heads (8:1)

Making a seated character stand

You might feel a bit confused to be told to make a seated character stand. However, basically this means, for example, drawing a seated 8:1 character standing.

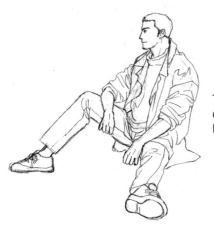

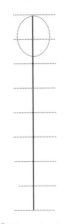

This is not to establish the head's length.

① Draw a layout at the target height.

② Since the target ratio is 8:1, divide the height into eight equal parts.

If you establish first the target head length, then the total height becomes eight times that.

Now the head's length is established.

Torso

Groin

Halfway mark

Legs

③ Decide the groin's position. Here, I set the groin halfway along the figure.

④ Once you have established the groin's position, the torso and legs are also automatically set.

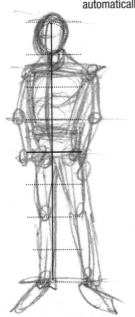

⑤ Draw according to the proportion layout.

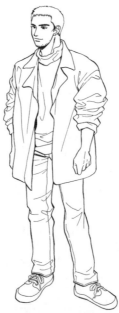

⑥ Final under drawing

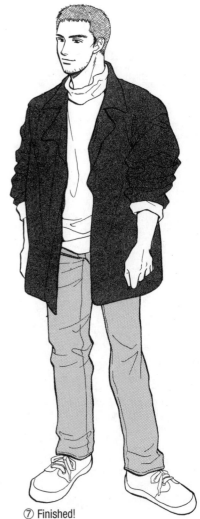

⑦ Finished!

93

Drawing yet another pose

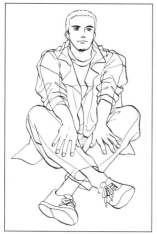

Target pose

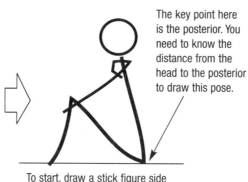

To start, draw a stick figure side view to help you understand the pose.

The key point here is the posterior. You need to know the distance from the head to the posterior to draw this pose.

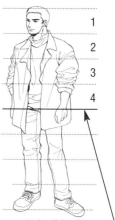

The posterior (hips from the front) is located about four heads down.

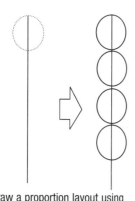

Draw a proportion layout using a 4:1 ratio.

Now your proportion layout is set.

Side view

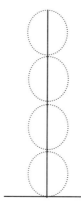

The distance from the knee to the foot is 2.5 heads. Use 2 1/2 circles in your proportion layout.

Here we see the final drawing. It has been drawn so that the body is visible from underneath. Normally, the body is not drawn in such detail, but I intended on this serving as reference for studying the relationship between figures and clothing.

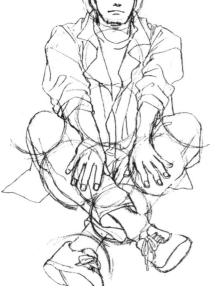

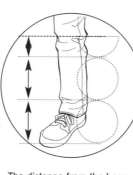

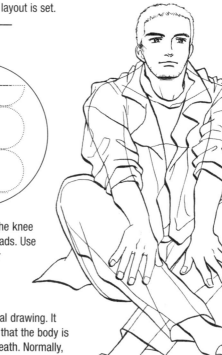

Drawing a Character within Defined Parameters (Frame or Panel)

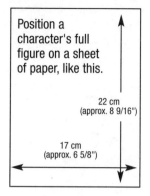

Position a character's full figure on a sheet of paper, like this.

22 cm (approx. 8 9/16")

17 cm (approx. 6 5/8")

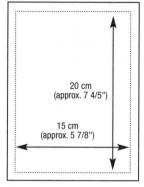

20 cm (approx. 7 4/5")

15 cm (approx. 5 7/8")

① Determine the inner margins.

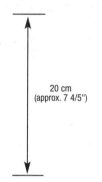

20 cm (approx. 7 4/5")

② A height for the character that fits exactly within these dimensions is then automatically set.

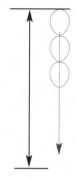

③ Decide the body-to-head ratio for the character.

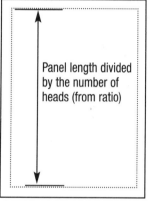

Panel length divided by the number of heads (from ratio)

④ Calculate the length of 1 head.

In the case of an 8:1 ratio:
20 cm ÷ 8 = 2.5 cm

11.2.5 cm (approx. 1")

If the head is drawn at 2.5 cm, then an 8:1 ratio character should be able to fit on this paper.

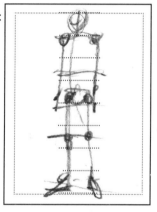

⑤ Draw a proportion layout for a 8:1 ratio figure.

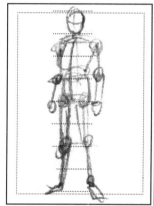

⑥ Build up the figure based on the layout.

⑦ Finished!

Check to see what body-to-head ratio you normally use for your characters. This will help you when you absolutely must draw a full figure within a panel.

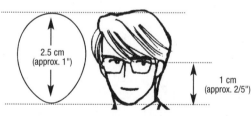

2.5 cm (approx. 1")

1 cm (approx. 2/5")

Note that the head size should include the hair. The actual measurement of the face in this instance is about 1 cm or 2/5".

Suppose you were to draw the face at 2.5 cm.

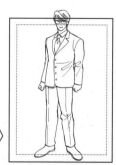

The head (or rather the hair) would stick out of the panel.

95

Drawing from a Photograph

Drawing a woman from a photograph of a man

When using a photograph or print as reference for a drawing, use the body-to-head ratio and proportion-balancing techniques.

Analyze the proportional balances of a man seated in a chair.

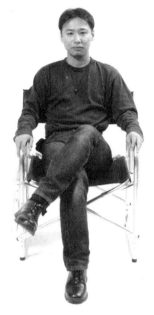

Let's say you would like to draw a woman seated in a chair but all you have is this photo.

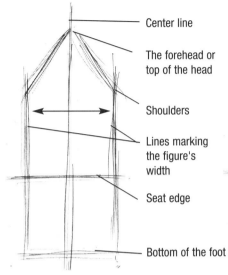

- Center line
- The forehead or top of the head
- Shoulders
- Lines marking the figure's width
- Seat edge
- Bottom of the foot

① Do a rough layout of the overall figure.

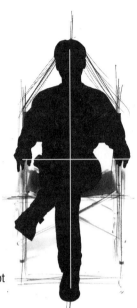

Create a silhouette image of the figure.

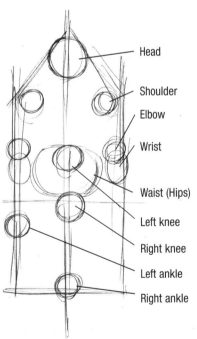

- Head
- Shoulder
- Elbow
- Wrist
- Waist (Hips)
- Left knee
- Right knee
- Left ankle
- Right ankle

② Roughly mark down where the joints lie to determine their positional relationship.

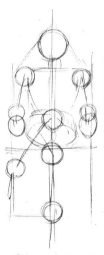

③ Sketch a layout of the whole figure while referring to the photo.

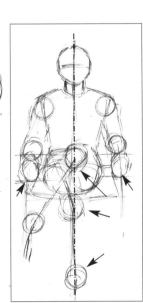

Key points in the layout

- The position of the knee of the top leg
- The face (head), knees and right foot are aligned along the vertical center line.
- The positions of both hands

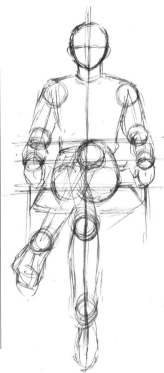

④ Capture the positional relationship of the joints as accurately as possible. The trick is to draw while picturing the contours of the body underneath the clothing.

Transform the layout of the man into a woman.

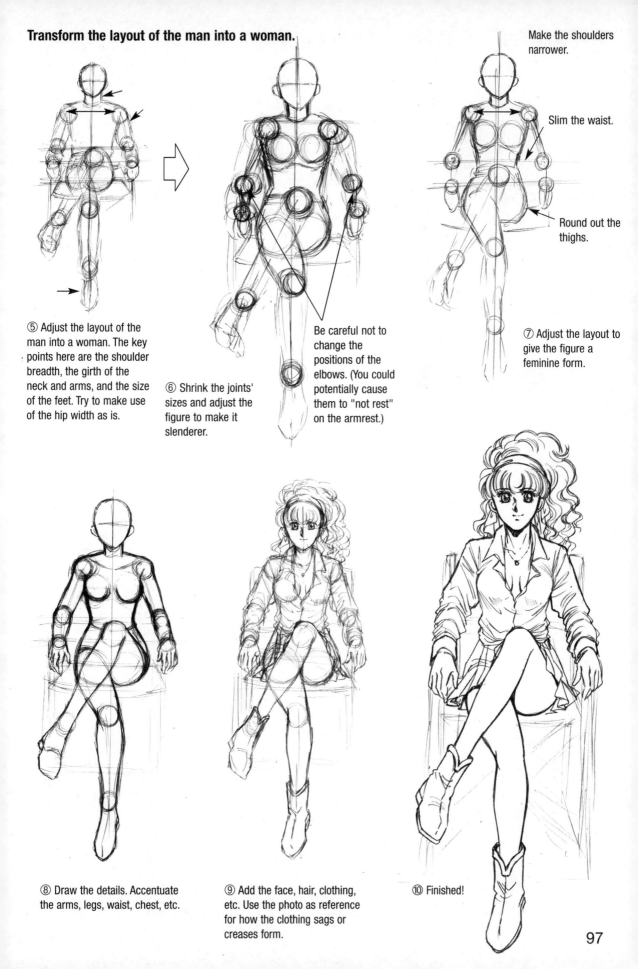

Make the shoulders narrower.

Slim the waist.

Round out the thighs.

⑤ Adjust the layout of the man into a woman. The key points here are the shoulder breadth, the girth of the neck and arms, and the size of the feet. Try to make use of the hip width as is.

⑥ Shrink the joints' sizes and adjust the figure to make it slenderer.

Be careful not to change the positions of the elbows. (You could potentially cause them to "not rest" on the armrest.)

⑦ Adjust the layout to give the figure a feminine form.

⑧ Draw the details. Accentuate the arms, legs, waist, chest, etc.

⑨ Add the face, hair, clothing, etc. Use the photo as reference for how the clothing sags or creases form.

⑩ Finished!

97

Drawing a boy from a photograph of a woman

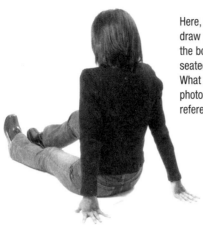

Here, your goal is to draw a back view of the boy to the right seated on the floor. What you have is this photo of a woman for reference.

The hips (groin) are critical in drawing seated poses.

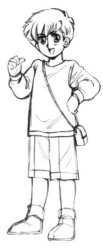

This boy has a body-to-head ratio of 5:1

The distance from head to hips is approximately 2.5 heads.

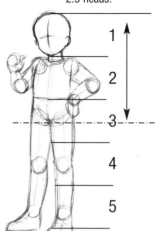

Refer to the body parts in the photo while drawing.

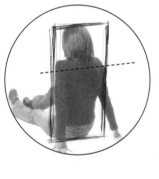

① Use the upper body as the front side of a block and sketch the layout. Use a block with angles that are as faithful to those in the photo as possible.

② Sketch the layout according to the body-to-head ratio planned for the seated character. (The distance from head to hips is 2.5 heads.)

③ Sketch the shoulders, arms, and back. The key point here is that the wrists and hips rest on almost the same line.

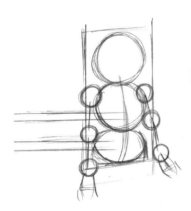

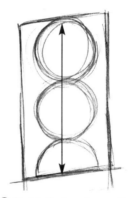

Think of the elbows and waist as visual points of reference.

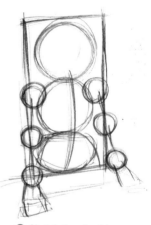

④ Note the positional relationships between the knees, the shoe toes, and the left arm.

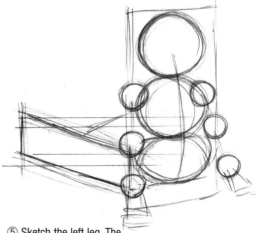

⑤ Sketch the left leg. The trick is to use angles faithful to those in the photo.

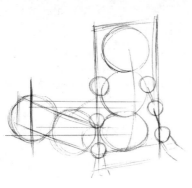

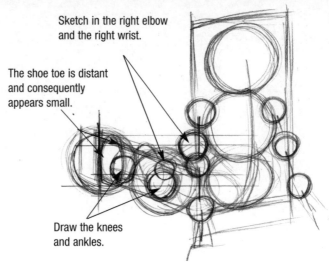

Sketch in the right elbow
and the right wrist.

The shoe toe is distant
and consequently
appears small.

Draw the knees
and ankles.

⑥ Here, a sketch has been made of
the leg. The leg is 2.5 heads long, but
since it is viewed from an oblique
angle, it is foreshortened.

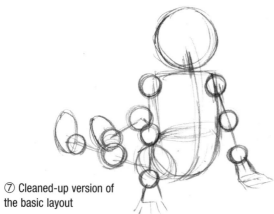

⑦ Cleaned-up version of
the basic layout

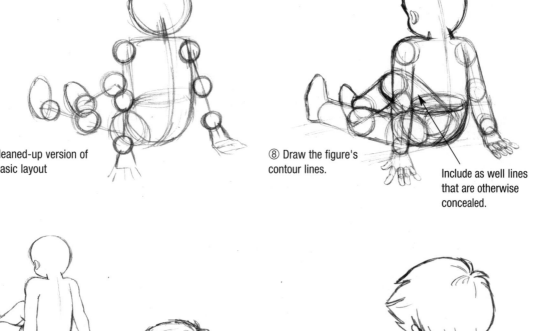

⑧ Draw the figure's
contour lines.

Include as well lines
that are otherwise
concealed.

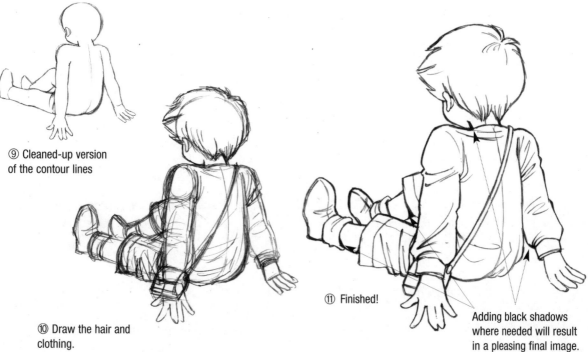

⑨ Cleaned-up version
of the contour lines

⑩ Draw the hair and
clothing.

⑪ Finished!

Adding black shadows
where needed will result
in a pleasing final image.

Differences in Proportions between Adults and Children

When drawing both an adult and a child together, you will first have to sketch layouts of the full figure before dividing up the figures according to the body-to-head ratio. This is crucial toward gaining an understanding of the visual height differences.

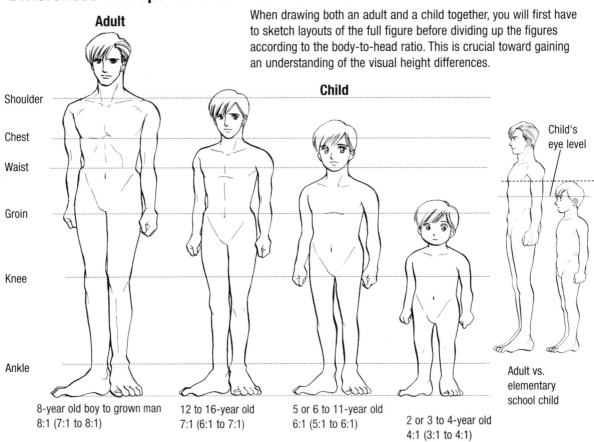

Adult

Child

Shoulder

Chest

Waist

Groin

Knee

Ankle

8-year old boy to grown man
8:1 (7:1 to 8:1)

12 to 16-year old
7:1 (6:1 to 7:1)

5 or 6 to 11-year old
6:1 (5:1 to 6:1)

2 or 3 to 4-year old
4:1 (3:1 to 4:1)

Child's eye level

Adult vs. elementary school child

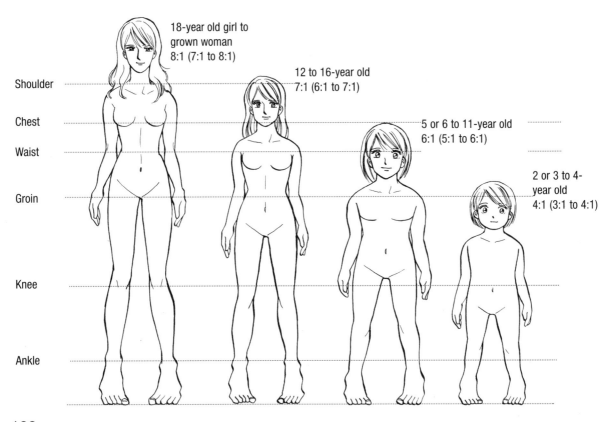

18-year old girl to grown woman
8:1 (7:1 to 8:1)

12 to 16-year old
7:1 (6:1 to 7:1)

Shoulder

Chest

Waist

5 or 6 to 11-year old
6:1 (5:1 to 6:1)

Groin

2 or 3 to 4-year old
4:1 (3:1 to 4:1)

Knee

Ankle

Differences in Hands and Feet

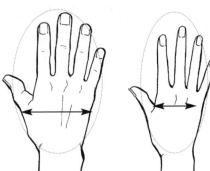

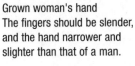

Grown woman's hand
The fingers should be slender, and the hand narrower and slighter than that of a man.

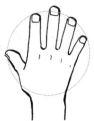

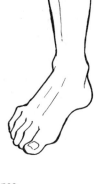

Grown man's foot
Accentuate the bony, angular appearance of the joints.

Grown woman's foot
Round off the joints and omit drawing the tendons.

Grown man's hand
The fingers are thick, and the hand broad. Include the joints. Give the back of the hand a sinewy appearance.

Child's hand
There is practically no difference between a boy's and girl's hand. The fingers are stubby, and dimples form at the knuckles.

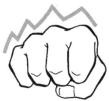

Grown man's fist
Add plenty of dips and protrusions and give it an angular appearance.

Grown woman's fist
The woman's fist is smoother with less dips and protrusions than the man's.

Child's fist
The child's hand is tiny with short digits, so give the fist a round appearance.

Child's foot
The child's foot is almost the same as the grown woman's foot but shorter.

Whether the proportional balances for men and women, children and adults are different, the elbows are approximately waist level and the wrists, groin level.

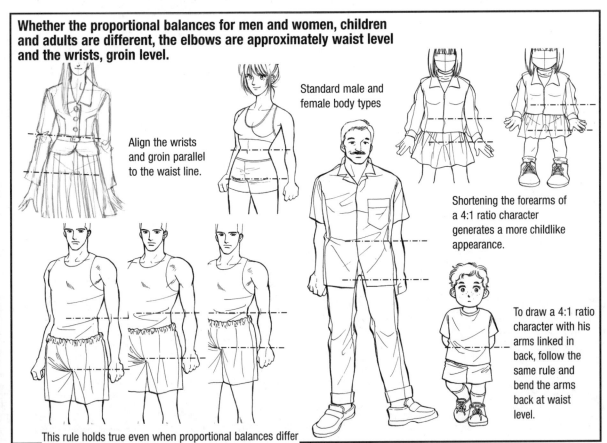

Standard male and female body types

Align the wrists and groin parallel to the waist line.

Shortening the forearms of a 4:1 ratio character generates a more childlike appearance.

To draw a 4:1 ratio character with his arms linked in back, follow the same rule and bend the arms back at waist level.

This rule holds true even when proportional balances differ (i.e. the waist and groin are situated at different levels).

Super-Deformed (*Chibi*) Characters

Drawing super-deformed(*chibi*) characters is extremely helpful for drawing regular characters as well.

1. Characters' facial expressions become more varied and dramatic.
2. It helps you study how the human body moves.
3. It is useful for not only dynamic action but also commonplace activities and minor movements.

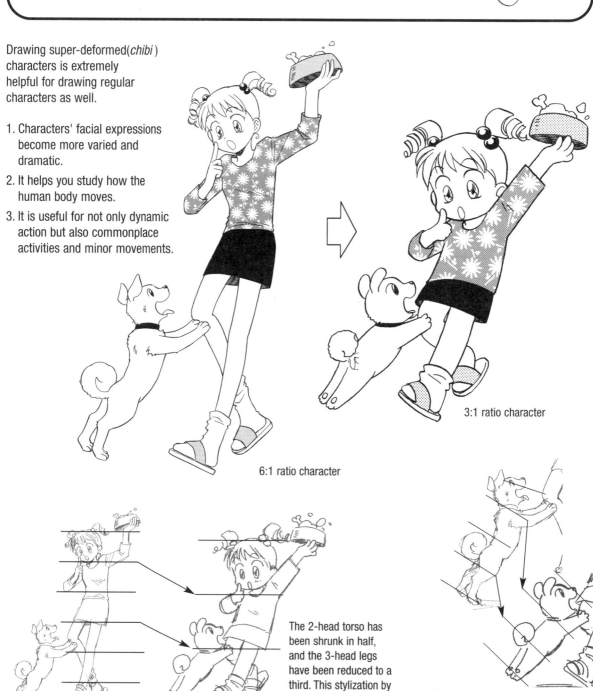

6:1 ratio character

3:1 ratio character

The 2-head torso has been shrunk in half, and the 3-head legs have been reduced to a third. This stylization by shortening is the hallmark of the *chibi* character.

Dogs too can be *chibi*-ized by shrinking a 4:1 ratio dog into a 3:1 pup.

How to Draw a Super-Deformed Character

Super-deformed (*Chibi*) character look faces

Exaggerate facial features.

1. Omit the nose.
2. Magnify the eyes' expressiveness.
3. Exaggerate the mouth.

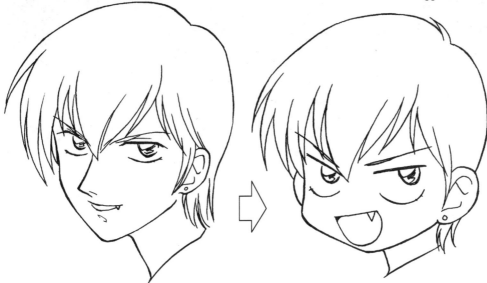

The slightly shifted eyes are now glinting. The nose is gone. The sneering mouth now sports a fang. The shape of the head has been simplified. The number of strokes used for the hair has been reduced.
The earring is still present. (The key is to retain any idiosyncratic features for the *chibi* character.)

Creating super-deformed characters by simplifying the faces

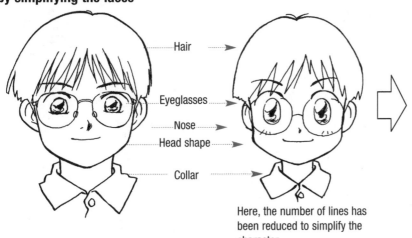

- Hair
- Eyeglasses
- Nose
- Head shape
- Collar

Here, the number of lines has been reduced to simplify the character.

The hair, head, glasses, eyes, nose, mouth, collar and all other elements have been simplified in form and rendered using less lines.

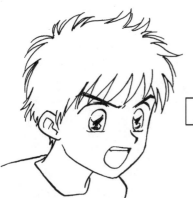

Typical *manga*-esque boy

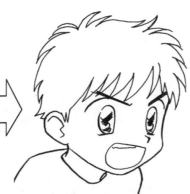

Here, the mouth and eyes have been enlarged, the ear has been simplified, and the number of strokes used for the hair reduced.

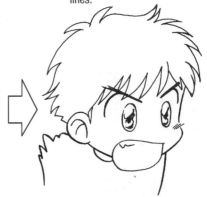

Here, the mouth is in its most stylized form to evoke the emotional state. The head has been squashed and rounded, resulting in a classic chibi face.

103

Big heads and short limbs do a super-deformed character make

Making regular characters look super deformed characters

• Transforming a 7:1 character into a 4:1 character

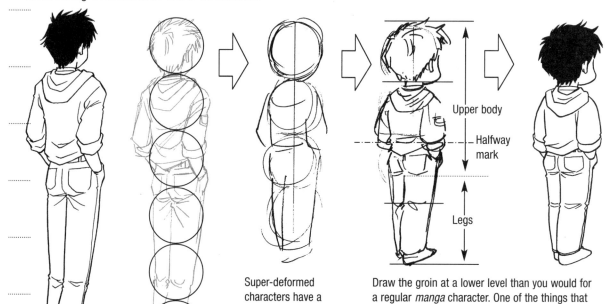

Super-deformed characters have a body-to-head ratio of 2:1 to 4:1. Since we are attempting here to create a 4:1 character, sketch a 4:1 figure layout.

Draw the groin at a lower level than you would for a regular *manga* character. One of the things that makes a chibi cute are its short legs.

Here, the above 4:1 character has been changed to a girl. Making the legs slenderer gives the figure a feminine feel.

• Transforming a 7:1 character into a 3:1 character

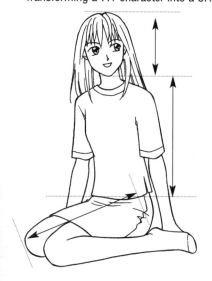

The trick is to determine which features to stylize.

Changing a super-deformed character into a regular character

Here we see a 4:1 super-deformed character

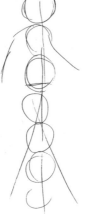

Divide the height into 7 heads.

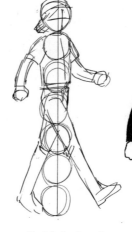

Sketch the layout for a 7:1 ratio.

Not only do you need to copy everything about the super-deformed character, including the way he wears his hat, but you also need to be aware of creating a sense of volume when drawing the cuffs, the belt, the shoes, and other details.

In addition, super-deformed characters' movements are often embellished. Consequently, you will need to tone down the movements of the arms and legs to natural levels.

Angles that do not allow calculation of the body-to-head ratio

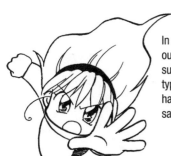

In this composition, the hand extends out toward the picture plane. Since super-deformed characters are typically drawn with tinier than normal hands, the hand is drawn either the same size as the face or smaller.

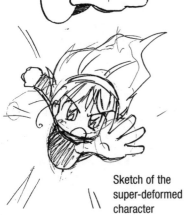

Sketch of the super-deformed character

In the case of a regular character, the palm is drawn larger than the face. At this angle, the thigh appears about the same size as the face as well.

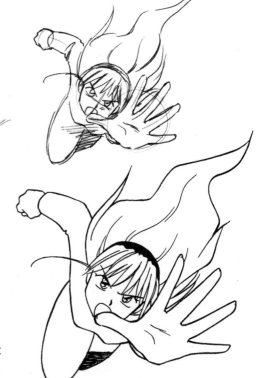

The body-to-head ratio of a regular character ranges from 6:1 to 8:1. Retain the idiosyncratic features of the super-deformed character and draw a regular 6:1 to 8:1 ratio character.

Render the hair in greater detail and elongate the face. Drawing the arm bending at the elbow further distinguishes the regular from the super-deformed character.

Adult and Kiddy Super-Deformed Characters

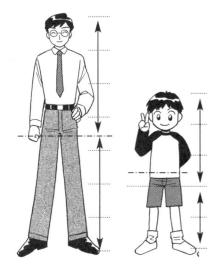

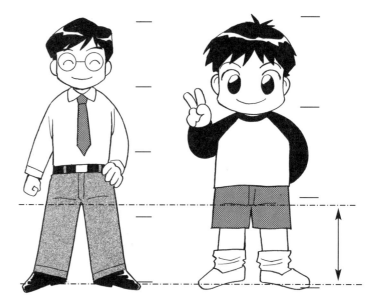

Adults have small heads and long legs. Children have big heads and short legs. Retain these differences when turning both into super-deformed characters.

The adult super-deformed character has a body-to-head ratio of 4:1 and short hands and legs.

The child super-deformed character has a body-to-head ratio of 3:1 and a big head, making him look like a kid.

Both characters have legs of the same length.

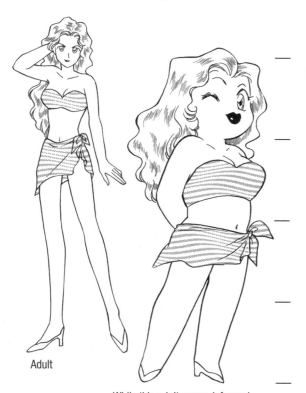

Adult

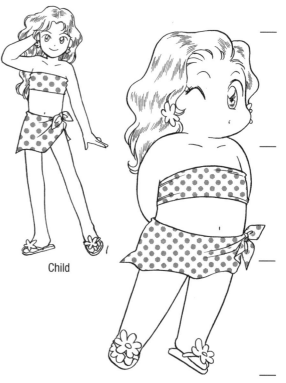

Child

While this adult super-deformed character's head may look extra big owing to her voluminous hair, she is actually drawn at a 4:1 ratio. The luscious lips and chest, waist and other adult characteristics have been retained but stylized.

This child super-deformed character has been drawn at a 3:1 ratio. Characteristics identified with adulthood have been eliminated to the extent reasonable. The arms and legs are smooth cylinders. Childlike characteristics have been retained and stylized.

Body-to-Head Ratios of Various Super-deformed characters

2.5 heads

3 heads

2 heads

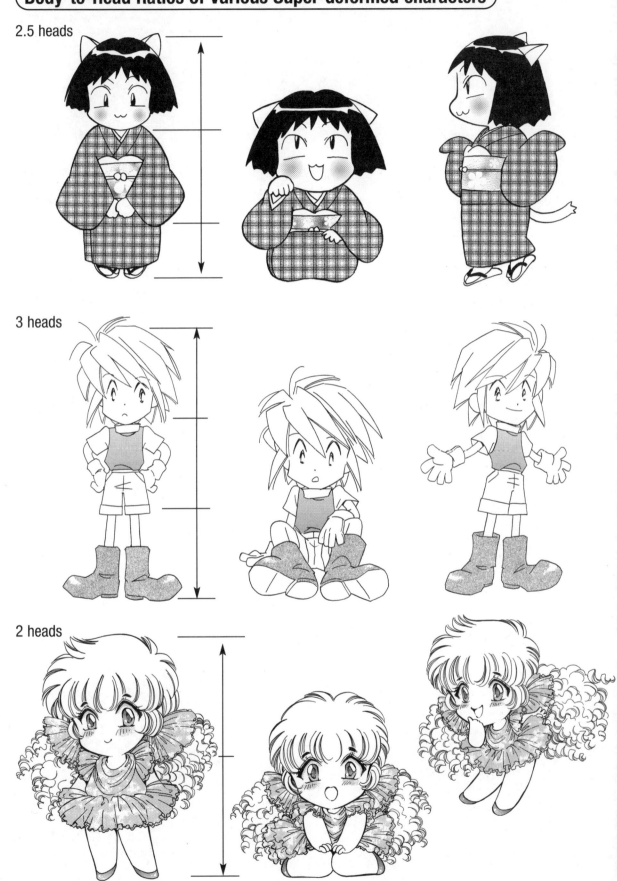

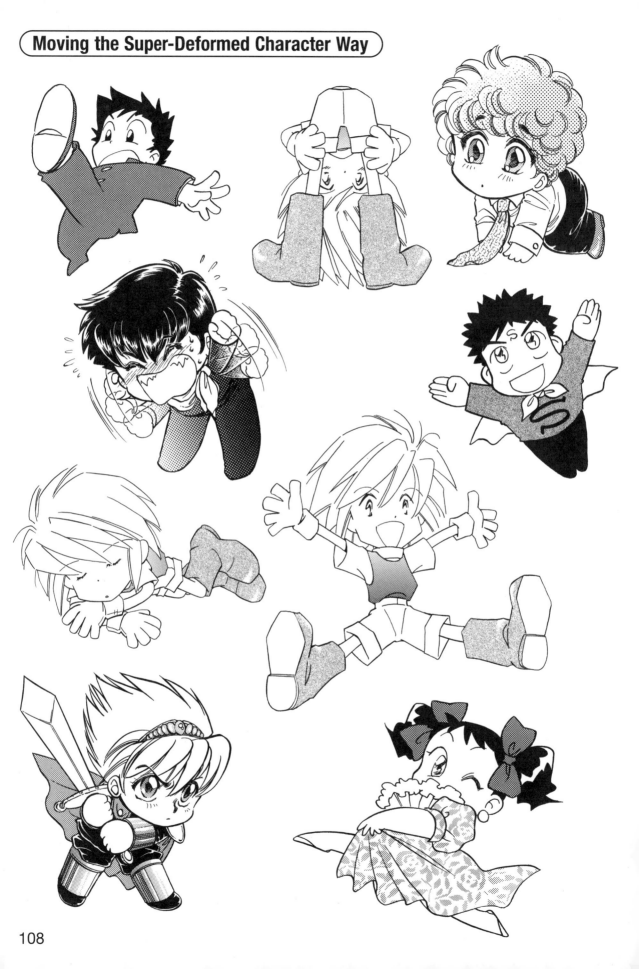

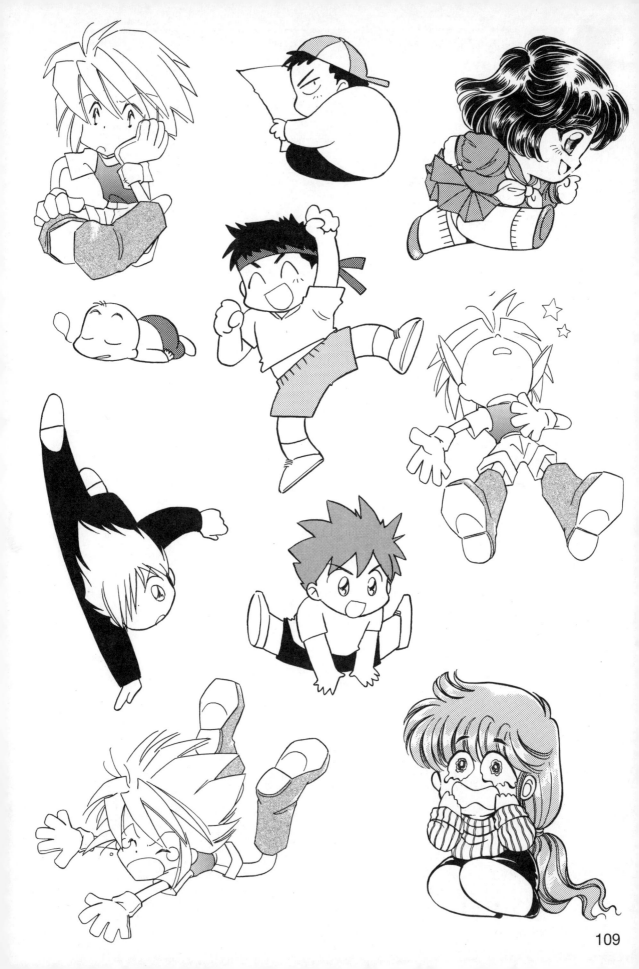

Good Posture: Giving Standing Figures an S-Curve

A realistic rendition of the posture when standing makes the figure look slouched. Posing the layout with an S-curve will cause the chest to stick out, giving the figure a visually pleasing posture.

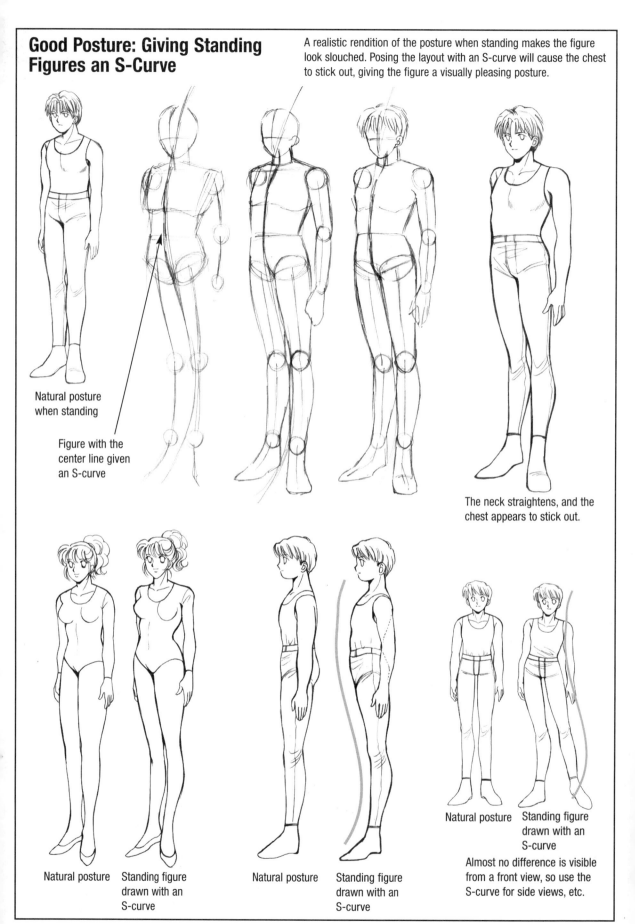

Natural posture when standing

Figure with the center line given an S-curve

The neck straightens, and the chest appears to stick out.

Natural posture

Standing figure drawn with an S-curve

Natural posture

Standing figure drawn with an S-curve

Natural posture

Standing figure drawn with an S-curve

Almost no difference is visible from a front view, so use the S-curve for side views, etc.

Chapter 4

Manga Miscellaneous

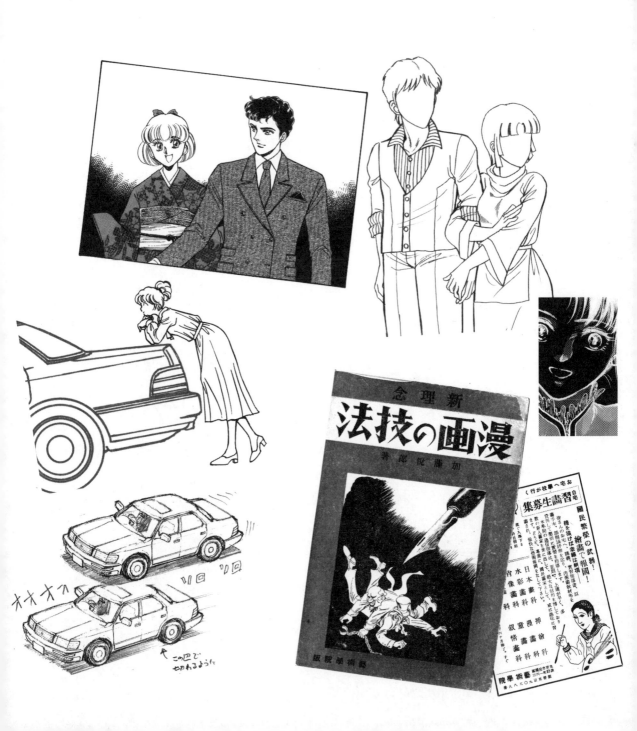

The *Manga* Clinic

Doctoring the cover

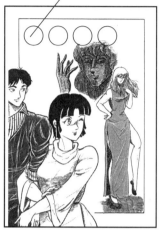

Space for the title

Cover of a work for publication
submission

Although it is just that the
man's head is small, the
impression is that of a face
seen at a distance.

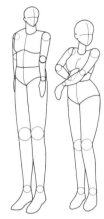

The arm is
bending
unnaturally.

The shoulders and
neck are not
connected naturally.

Creating a line drawing
of only the figure's
contours and tracing
the joints reveals to us
the problematic areas.

• Correcting the drawing

Key correction points

After correction

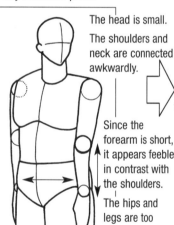

The head is small.

The shoulders and
neck are connected
awkwardly.

Since the
forearm is short,
it appears feeble
in contrast with
the shoulders.

The hips and
legs are too
thick.

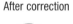

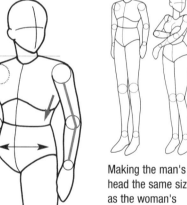

Making the man's
head the same size
as the woman's
improves the
overall balance.

Shoulders should be
even in height when
raised.

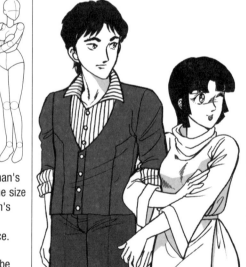

Final corrected image

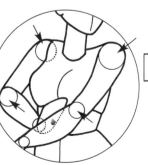

The right and left shoulders
and again the right and left
elbows are different sizes.

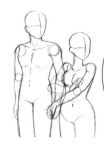

The man's
arm should
be drawn
first, then
followed by
the woman's
arm which
loops
through his.

Recomposing the cover

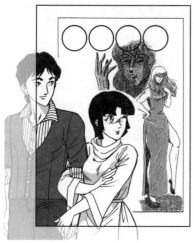

With the figures in their original position, the man is cropped off the page.

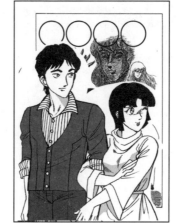

Yet, when the figures are shifted to the right so the man fits on the page, the rear character becomes obscured.

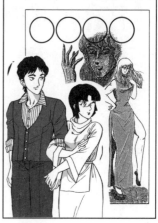

Shrinking the figures to allow view of the rear character causes the pair to become less prominent, making it unclear just who the main characters are.

Adjusting the composition

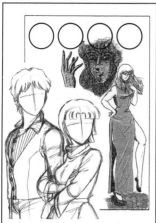

Since the goal is to maintain the pair's size while keeping the two within the panel, the composition will have to change.

Ideas for poses

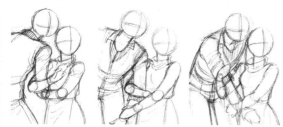

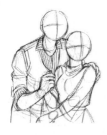

Artists use the cover to convey the work's contents or insight to the internal world to the reader with a single glance. Allowing a main character's face to be cut off is a big no-no. I also looked into a pose that would better represent the relationship between the two.

The woman's face is the same size that it was on the original, and the two fit neatly within the composition while retaining their relationship with the rear character.

Drawing Characters with Cars

Cars always appear on the scene with characters. Since the dimensions of a car (height and width) have all been established according to the human body, compare it to the characters' figures when drawing.

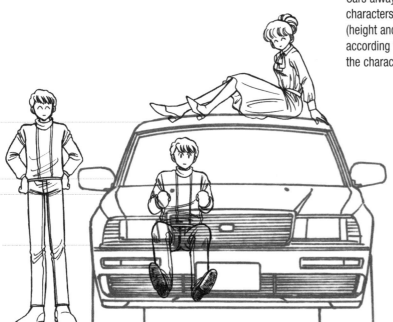

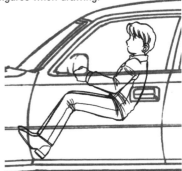

Make the car about as tall as a character's shoulder.

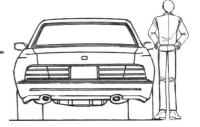

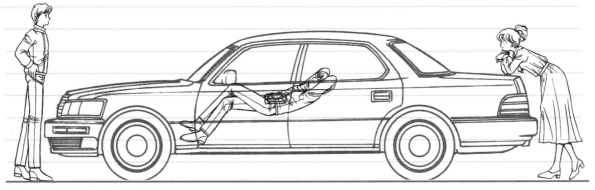

Pay careful attention to the positions of the doors and tires.

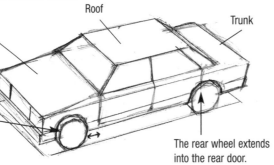

Hood

Roof

Trunk

The front wheels are centered underneath the hood, so keep a short distance between the front wheel and the front door.

The rear wheel extends into the rear door.

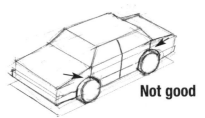

Not good

Having the front wheel extend into the front door results in an odd and unbalanced image.

The Car Drawing Process

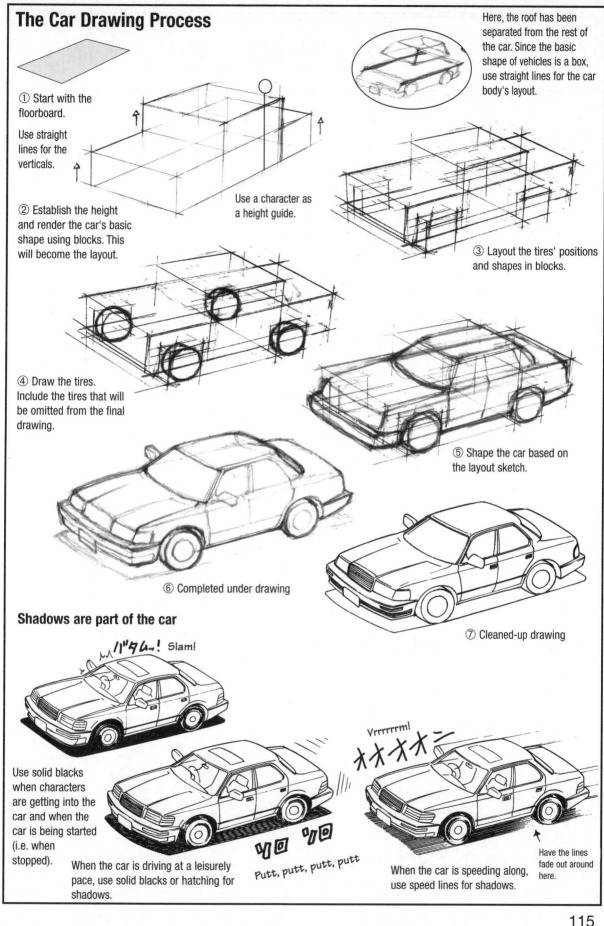

Here, the roof has been separated from the rest of the car. Since the basic shape of vehicles is a box, use straight lines for the car body's layout.

① Start with the floorboard.

Use straight lines for the verticals.

Use a character as a height guide.

② Establish the height and render the car's basic shape using blocks. This will become the layout.

③ Layout the tires' positions and shapes in blocks.

④ Draw the tires. Include the tires that will be omitted from the final drawing.

⑤ Shape the car based on the layout sketch.

⑥ Completed under drawing

⑦ Cleaned-up drawing

Shadows are part of the car

バタム! Slam!

Use solid blacks when characters are getting into the car and when the car is being started (i.e. when stopped).

When the car is driving at a leisurely pace, use solid blacks or hatching for shadows.

Putt, putt, putt, putt

Vrrrrrm!

オオオオー!

When the car is speeding along, use speed lines for shadows.

Have the lines fade out around here.

Common Minor Errors in *Manga*

Whether the right or left side of clothing goes on top-Both the girl's kimono and the man's suit should show the left side overlapping the right.

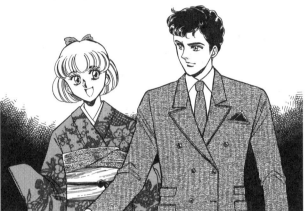

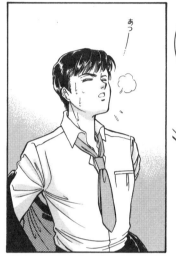

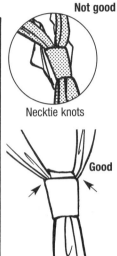

Not good

Necktie knots

Good

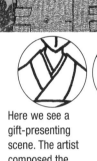

Swoosh

Um...

This is just a little thank you.

Here we see a gift-presenting scene. The artist composed the scene from the giver's perspective, resulting in an upside-down gift.

The characters and cord should face the recipient.

Not good

Good

Vertical stripes on kimono should not suddenly switch to horizontal stripes at the sleeves.

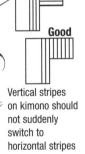

Not good

Good

How lovely! The cherry blossoms are in full bloom!

Early April
Furano-shi,
Hokkaido

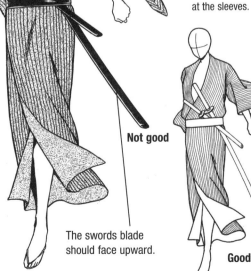

The swords blade should face upward.

In early April, Furano in Hokkaido (northernmost island of Japan) would still be covered in snow.